ABANDONED
QUEENS

RICHARD PANCHYK

AMERICA
THROUGH TIME®
ADDING COLOR TO AMERICAN HISTORY

America Through Time is an imprint of Fonthill Media LLC
www.through-time.com
office@through-time.com

Published by Arcadia Publishing by arrangement with Fonthill Media LLC
For all general information, please contact Arcadia Publishing:
Telephone: 843-853-2070
Fax: 843-853-0044
E-mail: sales@arcadiapublishing.com
For customer service and orders:
Toll-Free 1-888-313-2665

www.arcadiapublishing.com

First published 2019

Copyright © Richard Panchyk 2019

ISBN 978-1-63499-166-7

Typeset in Trade Gothic 10pt on 15pt
Printed and bound in England

CONTENTS

ACKNOWLEDGMENTS

T hanks to Lizzie and Matt for their company on some fun abandoned adventures. Thanks to Alan Sutton and Kena Longabaugh for their continued support and guidance.

All images courtesy of the author except for those on pages 19, 40, 41, and 52, courtesy of the US Geological Survey.

INTRODUCTION

With growth comes change, and Queens has certainly grown a great deal since it became part of New York City back in 1898. Life in Queens quickened with the advent of subway and railroad service from Manhattan, the construction of a bridge over the East River, and increasing popularity of the automobile. Sleepy villages were transformed into busy suburbs, and industry flourished. Those initial post-consolidation changes were followed by further evolution, and to this day Queens continues to evolve.

The main reason for the popularity of local history books is that they document the change that often obliterates the past, literally subjecting it to the swing of the wrecking ball. As a small kid in Elmhurst, I remember watching with fascination and trepidation out my second-floor bedroom window as the old house behind ours was demolished. What was happening? Why were they destroying that perfectly good old house? Was my house in danger, too? When I eventually saw the bigger, ugly building that replaced it, I still didn't have my answer.

That was my first taste of how progress can affect Queens. In the years that followed, I'd see plenty more growth and change in my neighborhood. For example, I saw the open space that was once my elementary schoolyard became the site of several massive additions to the original *circa*-1922 school as the population grew. Most recently, in 2018, the beloved old neighborhood Georgia Diner on Queens Boulevard closed its doors and was demolished to make way for an apartment building. Change is a constant in Queens–not just in my neighborhood, but all across the borough.

Yet, total destruction and replacement is not always the end result. Sometimes a place outlives its usefulness, but there is no plan for site reuse, or perhaps only a

partial plan or a partially implemented plan. There are plenty of places in Queens where traces of the past linger, haunting reminders of the way things used to be, sometimes hidden and sometimes in plain sight. This book is a visual journey through some of these amazing abandoned places. Because Queens is so densely populated, these abandoned places usually coexist adjacent to living, thriving locations, making for an often eerie and beautiful juxtaposition of old and new, used and unused. Some of the sites featured in this book await a hopeful fate of reuse and rejuvenation; the abandoned LIRR Rockaway line is slated to become Queensway, a multi-use recreational trail, for example. Other sites are already being transformed, such as some of the old buildings at Fort Totten that are being restored and repurposed.

No matter their eventual fates, none of the places in this book are static. As time passes, each site faces one of three fates—crumbling and deteriorating further, getting restored and reused, or finally being demolished altogether. The images in this book, therefore, are snapshots in time, capturing a moment in the ever-changing timeline that abandoned places experience. In their haunting beauty, you can see both glimpses of the past and hope for the future.

Warning: Abandoned places can sometimes be treacherous and are thus best enjoyed safely within the pages of this book!

1

THE LONG ISLAND MOTOR PARKWAY

T he longest-abandoned site in this book is also the earliest example of reuse. The Long Island Motor Parkway, also known as the Vanderbilt Motor Parkway, was the brainchild of William Kissam Vanderbilt, Jr. (1878-1944), a wealthy heir to the Vanderbilt family fortune. Vanderbilt was one of the nation's first automobile enthusiasts, maintaining a collection of cars as early as 1900 or so. Vanderbilt was such an auto enthusiast that he even started a racing competition–on local roads, which made him realize that these old-fashioned roads were really not intended for fast automobiles. He decided to build a highway just for cars, a grade separated, limited access concrete highway (the country's first) that would span from Queens through Nassau County and well into Suffolk County. Construction started in 1908 in Bethpage (Nassau County) and continued to points east and west. The Queens portion of the road began in Fresh Meadows and headed south briefly before heading east parallel to and just north of Union Turnpike. In Queens Village, the highway turned northeast and continued along that course until the Nassau County line, crossing Little Neck Parkway and passing through Glen Oaks on the way.

As innovative as this highway was, within two decades it was already obsolete. Bigger, faster automobiles and a growing population in the New York metropolitan area meant that newer, wider highways were needed. With the construction of the Grand Central Parkway/Northern State Parkway, the Motor Parkway was doomed. After it closed in 1938, Robert Moses, who was then NYC Parks Commissioner, purchased the Queens portion and immediately turned about two and a half miles of it into a bicycle path. The opening of the new path made front page headlines on the cover of Section Two of the July 11, 1938 edition of the *Long Island Daily Press*. More than 600 bicyclists used the path on the first day. The path (which is

now also for use by pedestrians) was also the beginning of the transformation (which is still ongoing today) of New York City into a bicycle-friendly place. Said Moses on opening day: "This is an experiment. The success of this path, the amount of its use and the way it is used will determine what we will do in the future in other parts of the city on this question of paths for bicyclists."

Though much of the pathway's surface has been repaved, there are still patches of original roadway and many of the concrete posts along the way are original to the parkway. Several of the original bridges carrying the parkway over other roads are also preserved. The Queens park sections of the preserved parkway were placed on the National Register of Historic Places in 2002. The Cunningham and Alley Pond Park sections of the Motor Parkway are a great example of a happy ending for an abandoned Queens place. Hopefully, other locales featured in this book will also experience the same kind of thoughtful reuse and preservation.

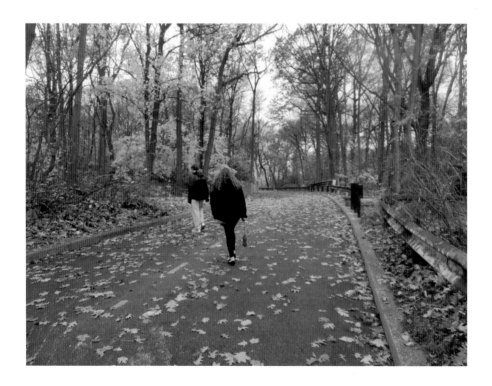

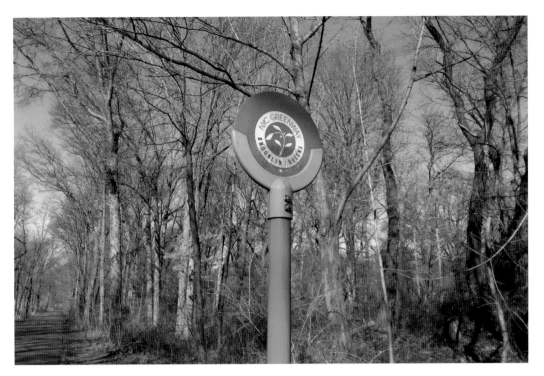

Sections of the original Long Island Motor Parkway in Queens have been preserved as part of the NYC Greenway, a bicycle and pedestrian path.

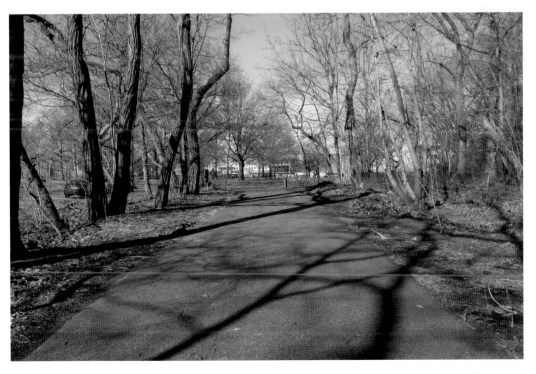

The preserved sections begin near the western terminus of the Motor Parkway in Fresh Meadows, in Cunningham Park and adjacent to Francis Lewis Boulevard. This photo looks back at the start of the trail.

An early bend gets you from the sidewalk to the trail.

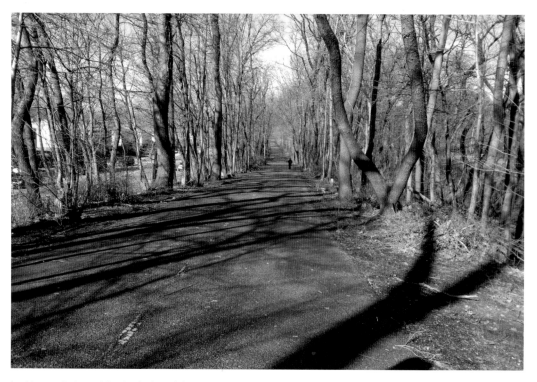

Looking north toward the beginning of the trail. That's 199th Street on the left, which runs alongside this part of the Motor Parkway trail.

There are numerous original concrete posts along the trail, and some are interestingly broken, revealing the reinforcing steel inside.

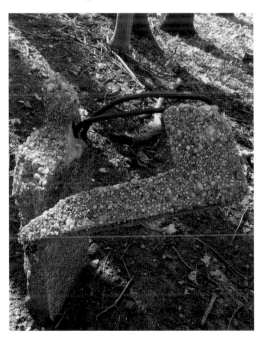

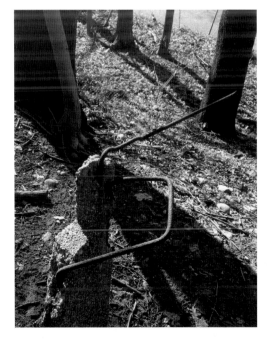

This is the original Motor Parkway Bridge over 73rd Avenue.

A concrete post is semi-hidden in a mound of dirt off the east side of the trail.

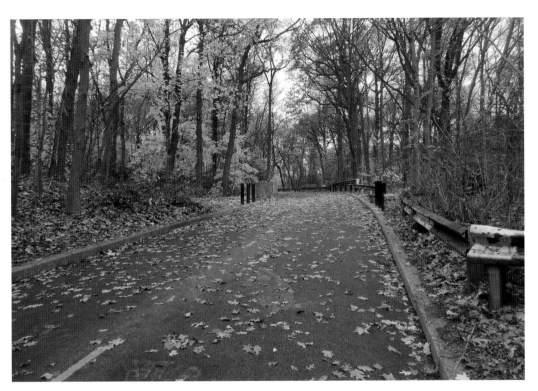

This photograph jumps to the Alley Pond Park section of the Motor Parkway trail, just off Winchester Boulevard, more than a mile east of the preceding images. This section of the trail is more isolated and feels almost rural.

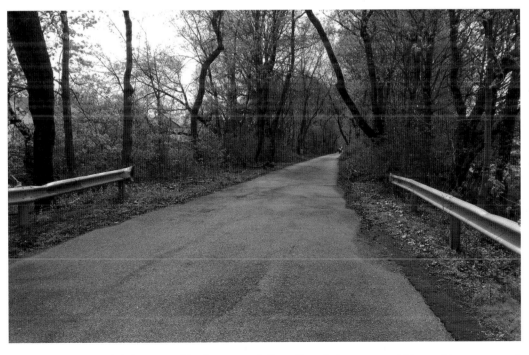

The pavement is in better condition in some spots than others, but no cars are driving on this anymore, so it doesn't matter as much.

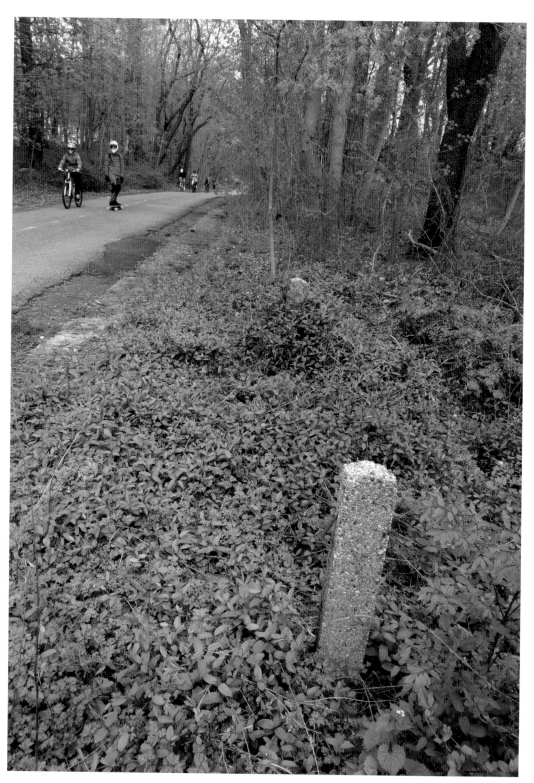

Concrete posts are visible in the Alley Pond Park section as well. Note the skateboarder and bicyclists. At times you could walk the trail and see literally nobody; other times it's a non-stop parade of people.

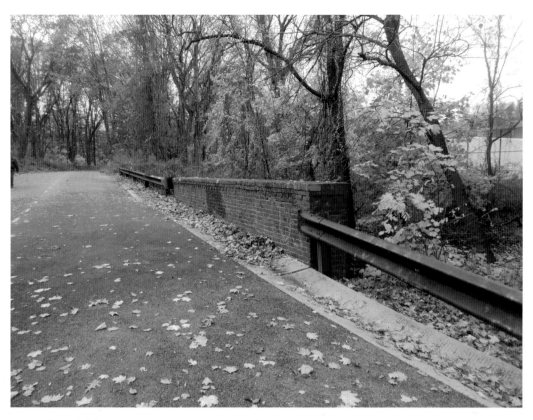

Several of the original Motor Parkway bridges in Queens are preserved, including this attractive red brick bridge over a park road. The brick façade was added in 1972.

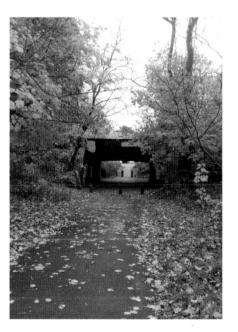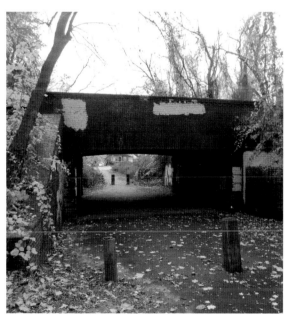

These two photos show the Wheeler Farmway bridge from below. Autumn is an especially fun time to visit the trail because of the pretty foliage from the many trees along both sides of the former Motor Parkway.

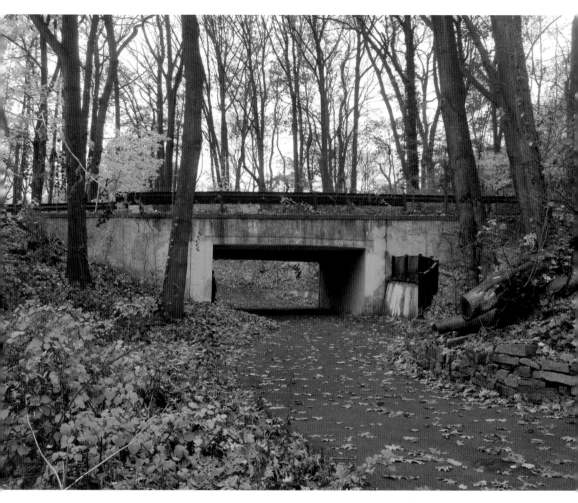

Another of the Alley Pond Park Motor Parkway bridges as seen from below. The sixty-five bridges along the original Motor Parkway were quite varied in size, style, and appearance.

2

THE ROCKAWAY BEACH BRANCH OF THE LONG ISLAND RAIL ROAD

G rowing up, abandoned railroad tracks were the kind of thing I pictured in the distant ghost towns of the Wild West, not a mere few miles away from my childhood home in Elmhurst. Little did I know that just off Queens Boulevard in the next town over from me, Rego Park, was the start of three-and-a-half miles of abandoned railroad tracks.

If you're from Queens, chances are that, like me, at one time or another you've probably driven under or over this long-abandoned and little-known Rockaway Beach Branch line of the Long Island Rail Road without even realizing it. There are abandoned rail bridges over Yellowstone Boulevard and Fleet Street in Forest Hills, for example, and Myrtle Avenue at Forest Park goes over the abandoned tracks. That's often the case with abandoned places in urban areas; you may pass right by without even realizing what you're passing, in part because you're so used to seeing it that you don't think to question what its function is. How many of us have passed the New York State Pavilion in Flushing Meadow Corona Park and really realized that it is technically abandoned and has been for years?

The Rockaways have been a popular summertime destination since the nineteenth century, but due to its relatively remote location, getting there was not always so simple. In 1877, work was begun on a rail line that would connect parts north with the beachy delights of the Rockaways. All was swell until the mid-twentieth century, by which time the automobile was an easy way to reach the Rockaways. After the City of New York City acquired the line from LIRR in 1956, the southern part of the rail line was converted into subway tracks for use by the A line, finally providing a subway connection to the Rockaways. Railroad service was reduced and ended for good in 1962. The tracks and bridges have been unused ever since.

Though much of the line is hard to access, there is a stretch of track just north and south of Myrtle Avenue, running alongside Forest Park, which is accessible– and fascinatingly otherworldly. Down along the tracks, there is a feeling of vintage desolation. It is like that imagined ghost town of my childhood, come to life in central Queens.

There are plans in the works to convert parts of this unused rail right-of-way land into multipurpose parkland. After the successful reuse of old rail tracks in Manhattan (the High Line along the lower west side of the city), a group of citizens proposed a plan for the reuse of the Rockaway Beach Branch. The Friends of the QueensWay was formed in 2011 to develop a plan and would have six themes: Care and Stewardship, Safety and Comfort, Culture and Economic Development, Ecology and Education, Play and Health, and Connections and Neighborhoods.

With time, money, love, and effort, this dream can come true, and the old rail line can get new life as a fun, invigorating recreational space. But right now, the Rockaway Beach Branch takes its deserved place in this book among the other haunting places in Queens.

*While I knew nothing of this abandoned rail line as a kid, I do have a distinct memory of taking the LIRR from the now defunct Elmhurst station to Port Washington when I was about seven. The station was closed and demolished in 1985 and there has been no LIRR service from Elmhurst since then.

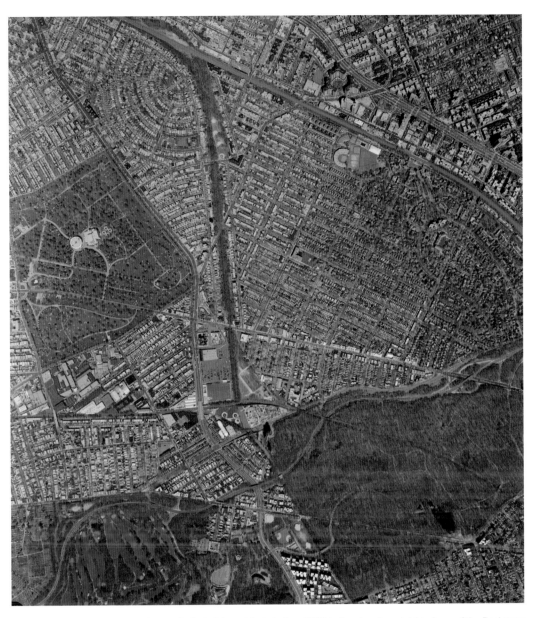

The brownish strip running vertically in this aerial photo from 2002 is the abandoned right-of-way of the Rockaway Beach Branch of the LIRR.

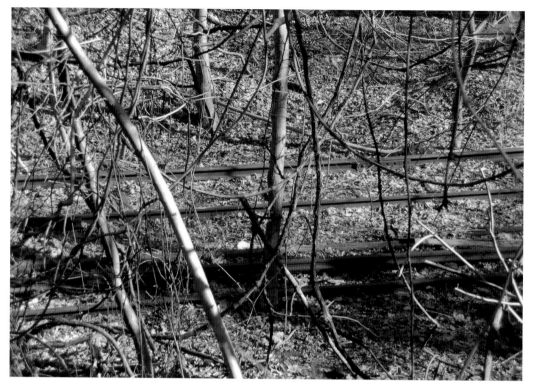

A view looking down onto the train tracks from just north of Myrtle Avenue.

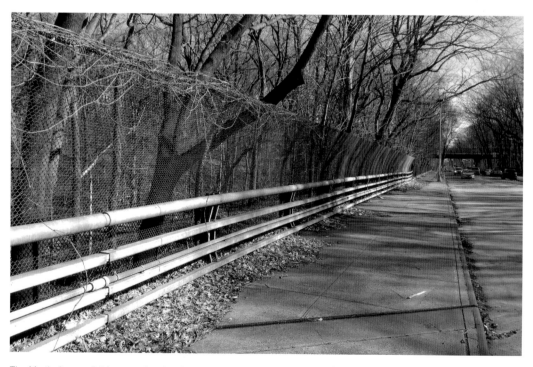

The Myrtle Avenue Bridge over the abandoned tracks. Driving over the bridge, you'd never know what lies below. Walking along the bridge, you'd spot the tracks if you knew what you were looking for.

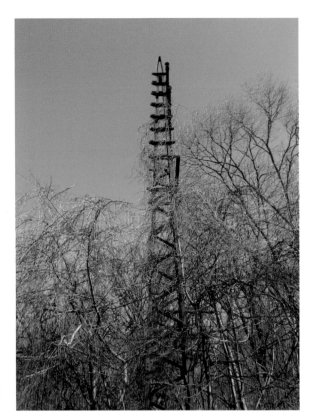

Right: A vintage electric line tower is visible from Myrtle Avenue just south of the bridge.

Below: Walking alongside Victory Field leads to the pleasantly meandering Park Drive, which winds through Forest Park. This is the Park Drive Bridge over the rail line.

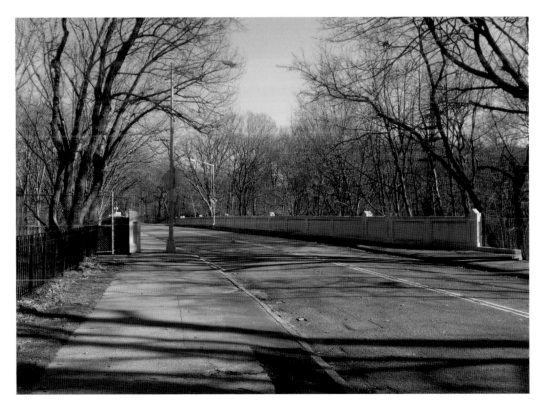

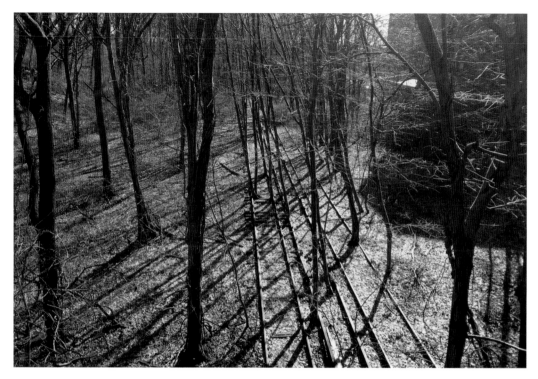

This view looks south from the Park Drive Bridge to the sunlit tracks below.

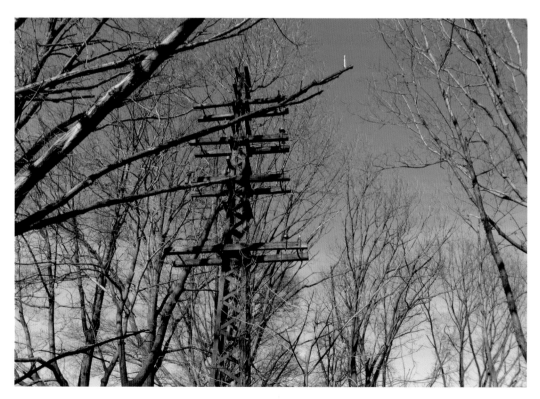

Great views of the ancient electric towers can be had from Park Drive.

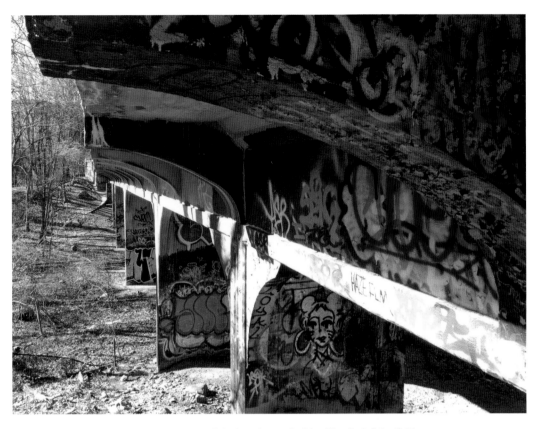

Descent to track level can be accomplished on the south side of the Park Drive Bridge.

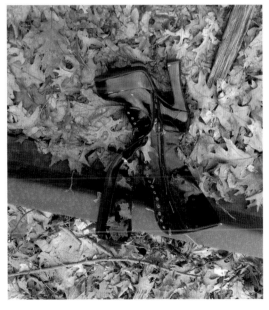

Above left: A rusted old spray-paint can hints at the graffiti that can be found on the bridge abutments.

Above right: A lone woman's boot lies chillingly on the abandoned tracks.

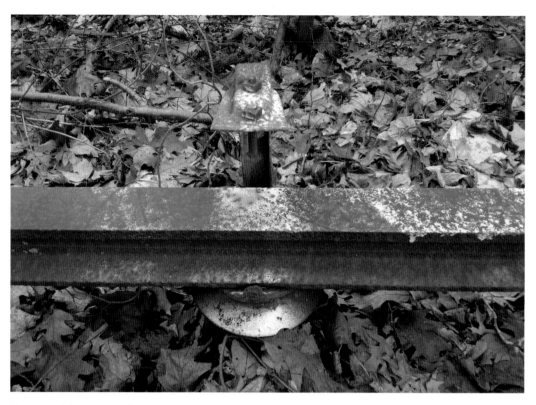

Close-ups of the abandoned and long-since de-electrified third rail.

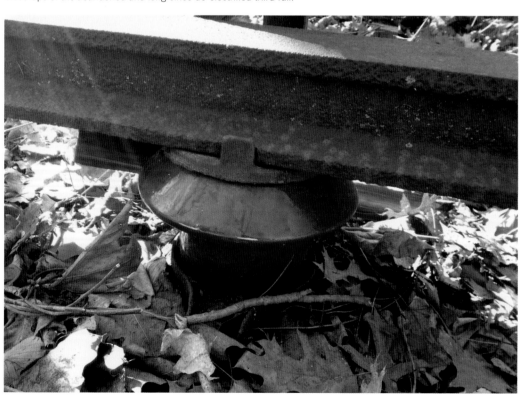

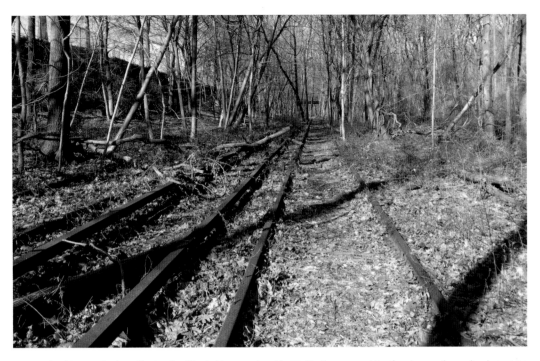

Looking north along the tracks. The bridge up ahead is Myrtle Avenue and the fencing up the embankment on the left is the border of Victory Field.

The tracks are littered with rail-related hardware.

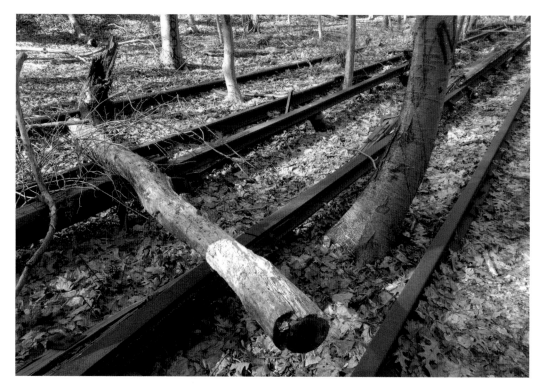

Trees grow between the tracks and fallen limbs lay on them, a welcome reminder that no trains will be coming anytime soon.

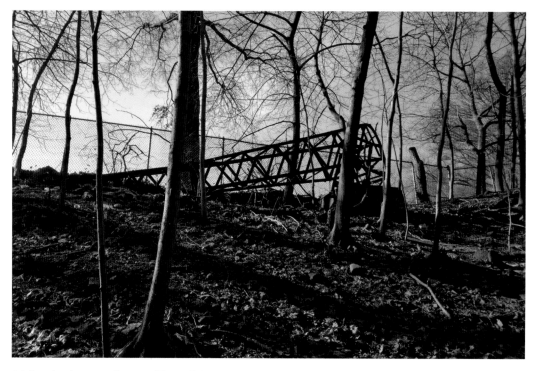

A fallen electric tower adjacent to Victory Field.

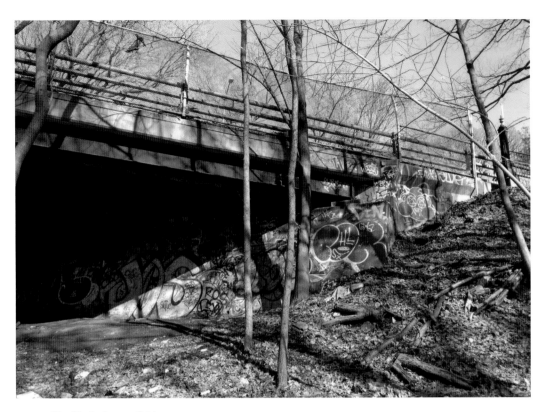

The Myrtle Avenue Bridge.

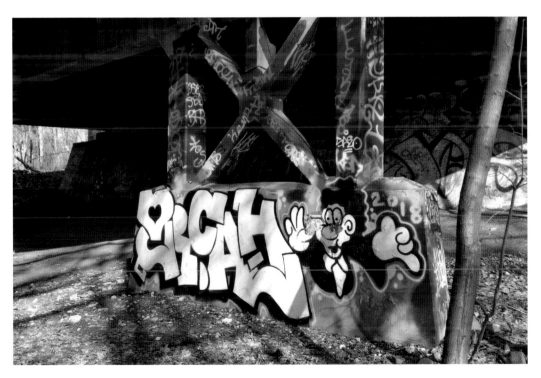

Colorful graffiti on the Myrtle Avenue Bridge substructure.

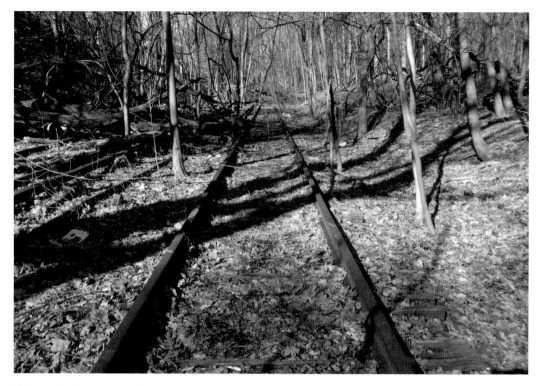

This stretch of track north of the Myrtle Avenue Bridge looks especially desolate and removed from the real world above.

The possible remnants of a track-level New Year's Eve celebration.

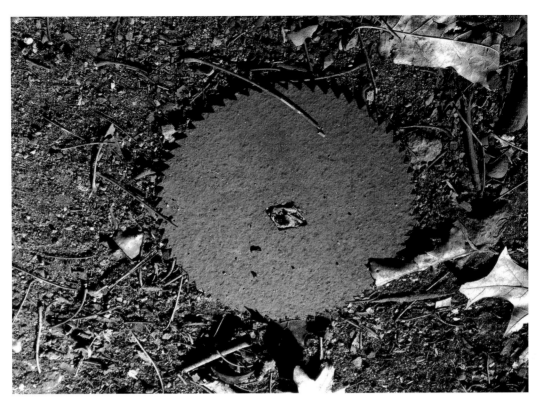

You never know what you'll find on abandoned properties. A saw blade on railroad tracks? Sure, why not!

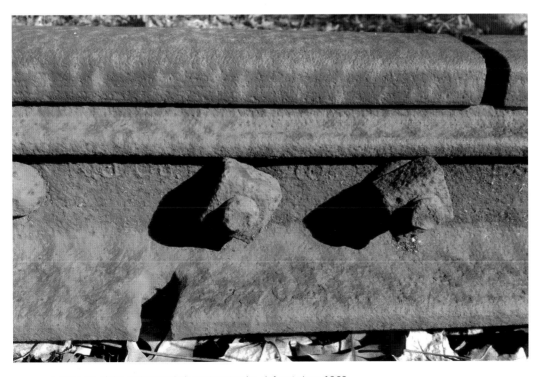

A close-up of the early twentieth-century tracks, defunct since 1962.

3

DEGNON TERMINAL

The catch phrase in real estate has always been location, location, location. For more than 250 years, Manhattan was THE location, but as all corners of the city became more crowded with offices and apartments, manufacturers began to seek new, cheaper, more spacious places to build factories and locate their warehouses and distribution centers.

Long Island City in the mid-nineteenth century had potential, being located near the East River and Newtown Creek, but without a rail connection to Manhattan–and the rest of the country–it was not quite ideal. By the turn of the twentieth century, however, there were massive projects in the works that would transform Long Island City's potential into reality.

It was only a matter of time before a developer seized the opportunity, and it so happened that developer was the Degnon Realty and Terminal Company, whose sister company had the contract to excavate the rail tunnel under the East River to connect Manhattan and Queens. In 1907, Degnon acquired 112 acres of land (part of which was underwater) in Long Island City. This land would be filled in with dirt excavated from their own work on the tunnels, and from soil dredged from Flushing Bay. Michael Degnon, the company's owner, was correct in anticipating that the various transportation improvements underway would transform western Queens. In 1909, the Queensboro Bridge (AKA 59th Street Bridge aka Edward Koch Bridge) opened, connecting Queens and Manhattan. In 1910, the Long Island Rail Road tunnels were opened, and train service could now begin between Manhattan and Long Island. In 1915, subway service was expanded into Queens.

Degnon knew that having a rail terminal nearby was not enough, so he had several miles of railroad tracks laid to connect with Long Island Rail Road tracks and lead

to the various buildings in "Degnon Terminal," so that goods could be brought by train literally right into a number of industrial buildings in the area.

The area's growth was phenomenal. In the four-year span between 1909 and 1913, more than 300 offices, factories, or warehouses were opened in anticipation of all the improvements to come. The Ford Motor Company had a factory that expanded from four stories to nine stories within a few years of opening in 1911. In 1913, the Queens Ford plant was turning out twenty-five automobiles per day (the number rose to fifty by 1914) from parts that were shipped from Detroit and assembled in Long Island City. Long Island City took off as an industrial hub, with eighty new factories opened there in 1919 alone. By 1928, of the 2,000 industries operating in Queens, 1,500 or 75% of them were found in Long Island City. Macy's and Bloomingdale's both had distribution warehouses in LIC. Everything from paint to textiles, from food products to shoes, from marble to furniture, was either manufactured or stored in Long Island City buildings.

According to a book published by the Queens Chamber of Commerce in 1915, if Long Island City was considered as a separate city, and not part of New York City, in 1914, it would have been nineteenth in population in the entire country, seventeenth in value of manufactured products, sixth in assessed valuation of its real estate, and fifth in physical area. Some of the major companies that moved to Long Island City in 1916 alone included the Organic Salt and Acid Company, the Loft Candy Company, the Fahnestock Electric Company (electric switches, battery connections, etc.), the American Hard Rubber Company, the Motometer Company (automobile accessories), the Siemund Wenzel Electric Welding Company, and the Mint Products Company.

According to a 1922 *Brooklyn Daily Eagle* article, industries that were present in LIC were almost representative of *all* the industries present in the entire country, and included: aluminum cooking utensils, barrels, beds, billiard tables, biscuits and cakes, boats, boilers, bottle caps, boxes, bottling supplies, burial caskets, candy, cans, carbon paper, celluloid novelties, chewing gum, cigars, clothing, copper refining, corsets, desks, drugs and chemicals, electric equipment, flashlights, foundries, furniture, gas works, hosiery, ink, ivory toiletware, knit goods, lamp stands, leather novelties, macaroni, machine works, motion picture productions, nitric acid, oil works, ovens, paint and varnish, paper products, pianos, pistons, playing cards, plumbing supplies, radio supplies, railway signal devices, ribbons, roofing, rubber items, sheets and pillow cases, shipping containers, shoes, silks, soap, starch, stationery supplies, store fixtures, stove and marble works, sugar, surgical tools, terra cotta, textile machinery, tools and dies, toys and dolls, typewriters, underwear, water meters, women's clothing, woodenware, and X-ray equipment.

Over time, the industrial prowess of the area began to fade as factories closed or relocated. Even today, the area south of Thomson Avenue still retains some of its past industrial glory, but many of the original buildings have been refurbished and reused for other purposes–the former Chiclets factory is now the headquarters of the New York City Department of Design and Construction, among other agencies. As for the old tracks, they were removed by the 1980s–mostly. But there are still a few places where the old tracks are visible. A walk along 47th Avenue reveals several glimpses of remaining Degnon terminal tracks, the most notable of which is at 31-00 47th Avenue, the Falchi Building (built in 1922 and formerly home to a Gimbels Department Store warehouse), which has two clearly visible sets of tracks leading to it.

A walk among the industrial buildings of Long Island City reveals the remnants of what was once an industrial terminal with numerous rail spurs leading to factories and warehouses.

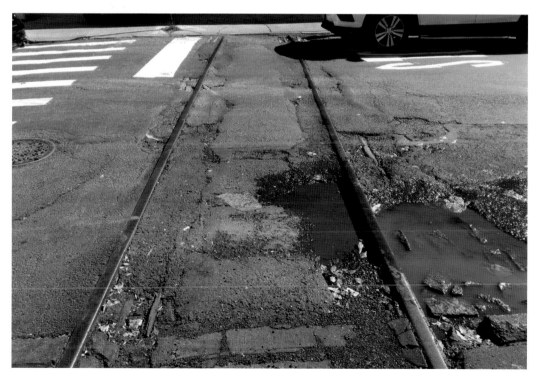

Some of the visible track remnants run parallel to and just south of 47th Avenue around 31st Street, made more prominent by the deteriorated roadway around them.

Above: Broken pieces of wood alongside the track remnants peek through the crumbling asphalt.

Left: How many people walk past these tracks every day without a second thought as to their original purpose? Unlike other places in the city with streetcar track remnants, these had an entirely different purpose.

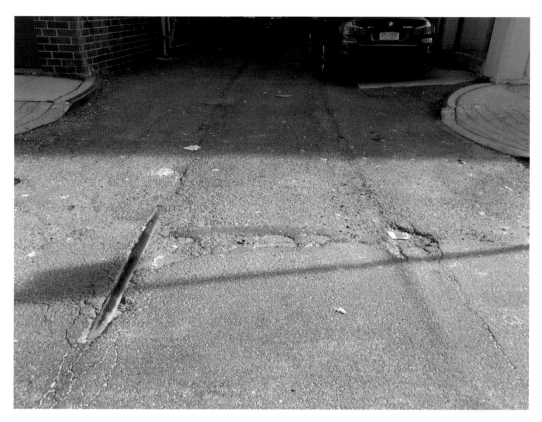

Explore the area and you'll find more old tracks. This segment runs through an alley between 30th Place and 31st Street, just south of Hunterspoint Avenue.

This double set of tracks leads right up to the steps to the Falchi Building at 31-00 47th Avenue, between 31st Street and 31st Place.

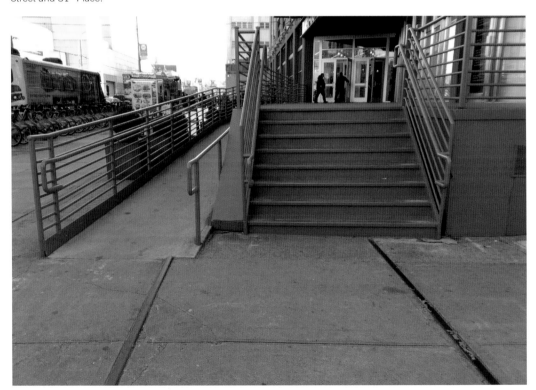

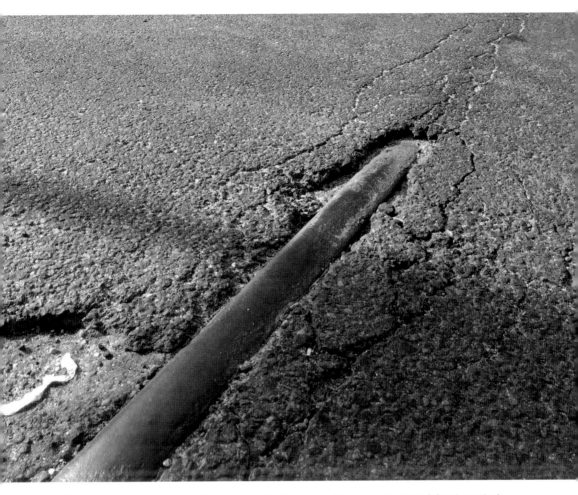

Why are some track remnants still exposed while the rest are either covered or gone? Good question!

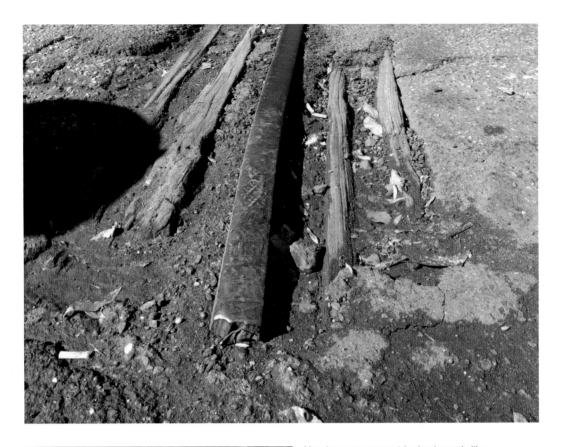

How long can severe tripping hazards like these exist on New York City streets? If you live in New York, then you know the answer: infinitely.

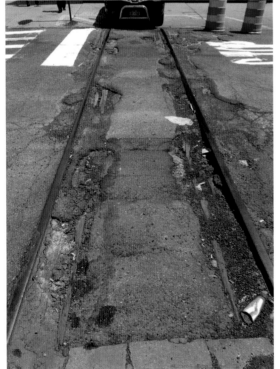

4

FLUSHING AIRPORT

Though physical growth and progress often comes at the expense of nature, once a place is abandoned, the tables are turned. It's amazing how quickly nature reclaims what it had lost. And it's not just old buildings crawling with vines, or obsolete railroad tracks overgrown with trees. The once thriving Flushing Airport, which opened in 1927 and closed in 1984, is now just a 70-acre overgrown wetland filled with grasses and wildflowers. Located in College Point just north of what was, as of 2019, a SmartPark parking lot for LaGuardia Airport, just east of the Whitestone Expressway, and just west of the *New York Times* distribution facilities, the Flushing Airport was always on tenuous ground, so to speak. Its runways were prone to flooding even during its heyday, so once it was finally shut down after years of decline, it didn't take long for nature to come on full force and take full control.

The airport had competition from nearby LaGuardia for most of its lifetime, and also complaints of proximity to local homes. Still, it outlasted another local small airport–Holmes Airport in Jackson Heights–by about twenty years. A fatal incident in 1977, when a plane that had taken off from the airport crashed into a nearby house, sealed the airport's fate and led to its closure under Mayor Ed Koch. Runway remnants are still there behind fencing and out of sight behind tall grasses, but can be seen in aerial views. The hangars and other buildings were demolished over the years. Until its reconstruction in about 2015, Linden Place, which runs north-south parallel to the airport site, was closed due to being overgrown and unstable. Reuse of the former airport site has been proposed for years, but nothing has occurred as of yet. Balancing what the public wants or needs with what developers want is tricky in urban places such as New York City. And sadly, it's often easiest to just let an abandoned place languish than to spend money and do something with it.

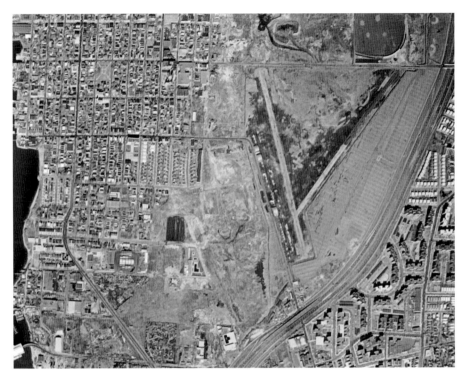

This aerial view from 1959 clearly shows the runways of the Flushing Airport.

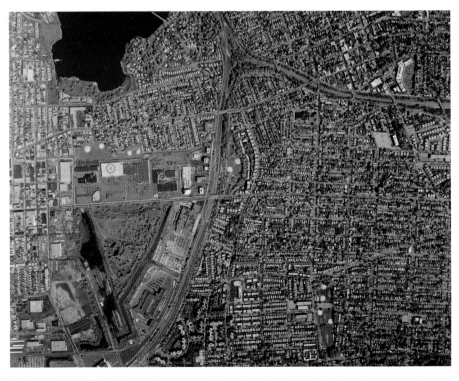

Fast forward to 2002 and the area has been reclaimed by nature. Note also how adjacent development has advanced. As of 2002, Linden Place was partly submerged and had not yet been reconstructed.

Above: This closeup shows abandoned hangar buildings that were still standing in 2002 right along Linden Place, but have since been demolished.

Right: The site of the former Flushing Airport runs along the east side of the recently reconstructed Linden Place, just north of the SmartPark lot for LaGuardia Airport.

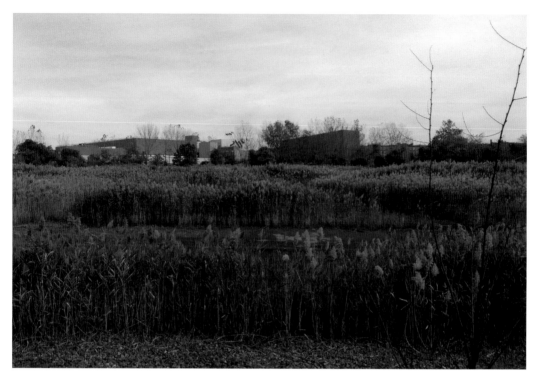

The airport site is now marshy grassland waiting for some unknown future development. The *New York Times* distribution center is visible to the east.

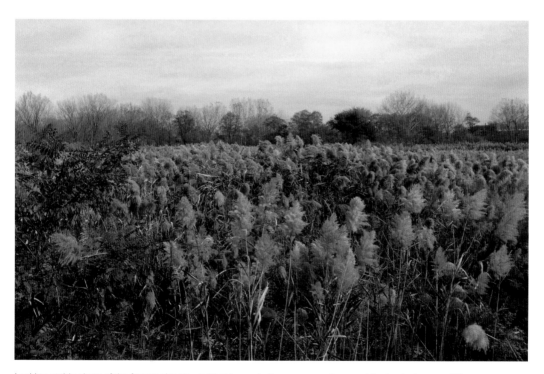

Looking at this photo of the former airport, you'd not even believe you were in one of the busiest areas of Queens, just a few hundred feet from a major movie theater complex.

Colorful wildflowers grow on the site through summer and fall.

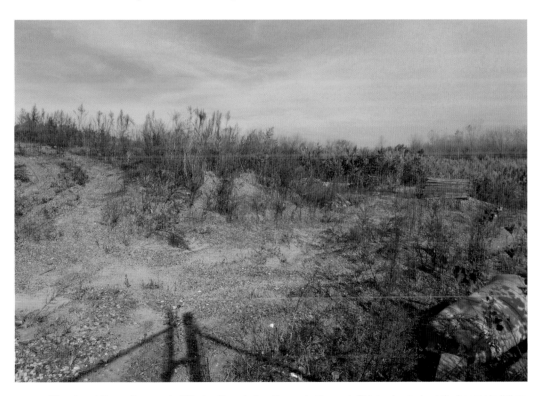

The view at the northern end of Linden Place before it veers to the west. This is about where the hangar buildings used to be.

5

SAMUEL LORD'S SUBURBAN EXPERIMENT

Progress is usually the force that causes buildings to become abandoned in the first place, and is also the force behind their eventual demolition. In one case in Queens, however, progress both destroyed and saved a piece of history (at least temporarily).

Samuel Lord came to the United States from England in the early nineteenth century and founded the department store that would become Lord & Taylor. Though his store was in Manhattan, he favored the country life and maintained a home in Elmhurst (then Newtown), Queens. But the retail business wasn't Lord's only interest. He was a real estate speculator as well and he had a vision for a new middle-class housing development. Just off Broadway in the heart of Newtown Village, he had four spacious new homes built in the 1850s, each with large yards. His idea was to create a model for the "new" living. He called it Clermont Terrace. The suburban thought was well ahead of its time, and didn't catch on the way he'd hoped. The houses wound up being rented to several families, and the properties subdivided.

By the turn of the twenty-first century, only one of these original suburban experiments was left. And then its fate was sealed when an apartment building was to be built on the site. Or was it? The house itself was destroyed, and the multi-story new brick building began to rise. But just as quickly as it had begun, work suddenly stopped. The apartment building was left unfinished, for whatever reason, preserving one last fragment of the final house: the stairs that once led to the front door of the house that Lord built. The ruins are found on an alley that is itself a relic of Lord's development–Claremont Terrace (note the spelling). Once part of a semi-circle that offered access from Broadway to this little enclave, the ramshackle dead-end alley is all that's left of Lord's infrastructure (and when I visited was also the site of

a homeless squatter living at the end of the alley). Because I am smart, I picked one of the coldest days of the winter to explore the remains, but despite my frozen fingers, I was rewarded by the cool remnants I saw. I knew that like everything else in this book, this piece of Queens history could be gone at any moment, but because it's on privately owned property, things could happen much more quickly.

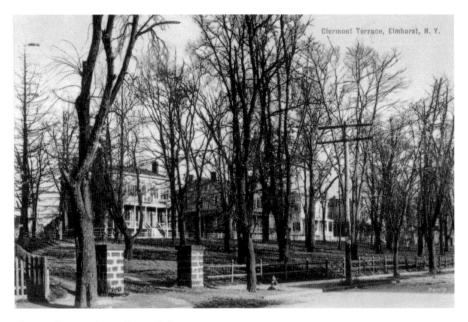

Clermont Terrace circa ealy twentieth century.

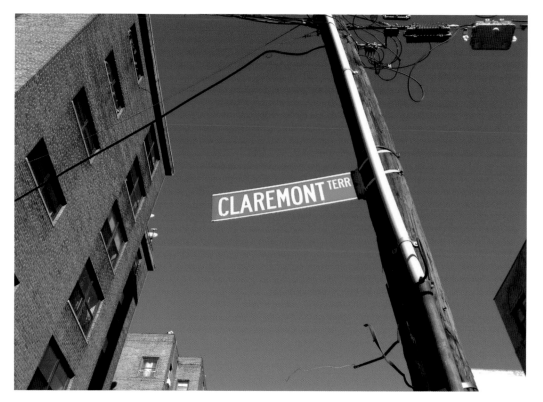

A sad little alley called Claremont Terrace in Elmhurst is home to the last remains of a nineteenth-century housing experiment.

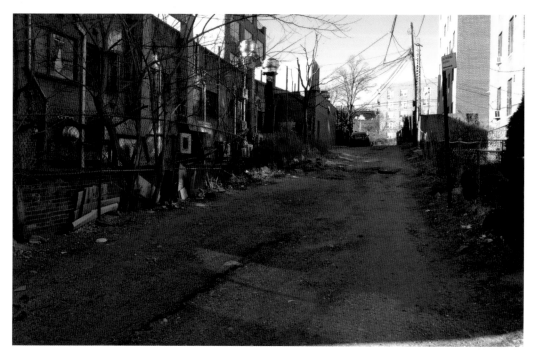

Not sure why this forlorn and lumpy strip of asphalt even deserves a street name!

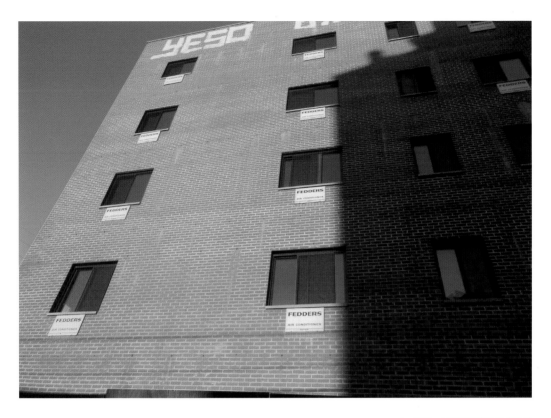

Above: Thanks to an unfinished and abandoned apartment building, a remnant of great historical significance still stands (as of 2019).

Right: The front steps that once led to the last of department store founder Samuel Lord's four experimental suburban model homes called Clermont Terrace.

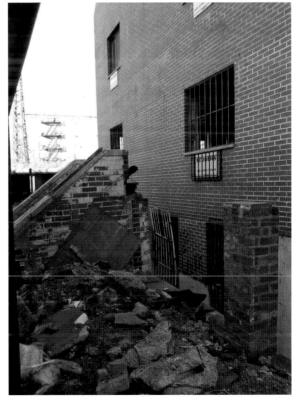

Judging from the advanced state of the adjacent apartment building construction, these steps could have been mere weeks or even days away from demolition when work on the building came to a halt for unknown reasons.

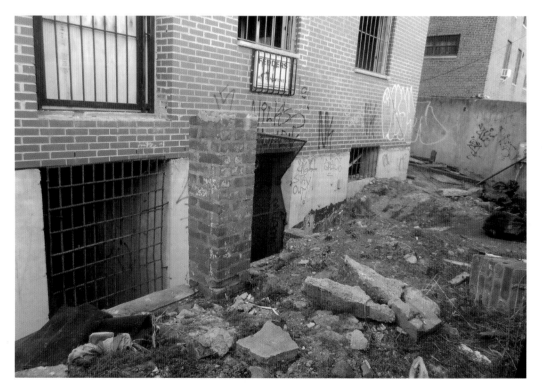

The remains of a brick column from the last of the Lord houses was probably part of the porch.

Bricks, branches, and construction debris sit on the steps that once led to a grand house on an oversized property. More construction debris lays on the ground nearby.

Scattered bricks likely from the demolition of the old Lord house are everywhere.

6

THE LOST NEIGHBORHOOD OF EDGEMERE

O f all the abandoned places I have visited, Edgemere in the Rockaways is the most hauntingly bizarre. It's also probably the largest, most prime chunk of undeveloped real estate in the entire city. Located along a twenty-three-block stretch of the eastern Rockaways, the area known as Edgemere was once a thriving seaside bungalow community, but by the late 1950s had declined to become nothing more than 300 crime-ridden acres of crumbling homes.

There was a growing chorus of cries to do something about this blighted area. In 1964, the New York City Planning Commission officially marked the area from Beach 32nd Street to Beach 84th Street as eligible for Federal aid to implement an urban renewal program, designed to wipe away crumbling areas and build new and improved housing instead.

Plans were made for the city to acquire the land and demolish the dilapidated structures, but the process took several years. In 1967, Deputy Mayor Timothy Costello flew in by helicopter to have a firsthand look at the conditions in the urban renewal area. By 1969, the work had begun - the land was acquired, families were relocated, and the bulldozer-powered demolition of hundreds of early-twentieth-century buildings was begun.

Despite plans for renewal, half a century later, much of the original destruction zone remains abandoned (the new Arverne-by-the-Sea development sits on the western edge of the renewal zone). Buckling, pothole-filled roadway remnants run south from the Rockaway Freeway between Beach 33rd Street and Beach 56th Street. What were once populated, lively southern Queens streets teeming with residents are now empty and overgrown with trees and shrubs. Just beyond the abandoned streets is the Rockaway Beach Boardwalk and the ocean.

What adds to the eerie feeling of the place is its popularity as a dumping ground. And I don't mean just random trash, a bottle here and a broken umbrella there. No, people seem to go to Edgemere with entire vanloads of garbage–with a household full of trash, entire rooms full of stuff just left to rot. It is easier for them, perhaps, than disposing of it properly according to NYC sanitation rules. Dressers, tables, tires, framed pictures, lace tablecloths, toys–anything and everything can be found here. It's ironic and poignant, actually–where once homes used to stand are now the contents of homes in other locations, brought here specifically.

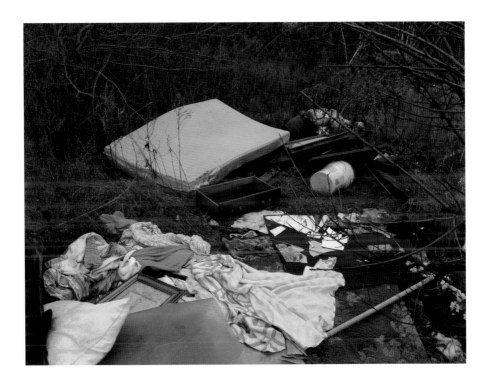

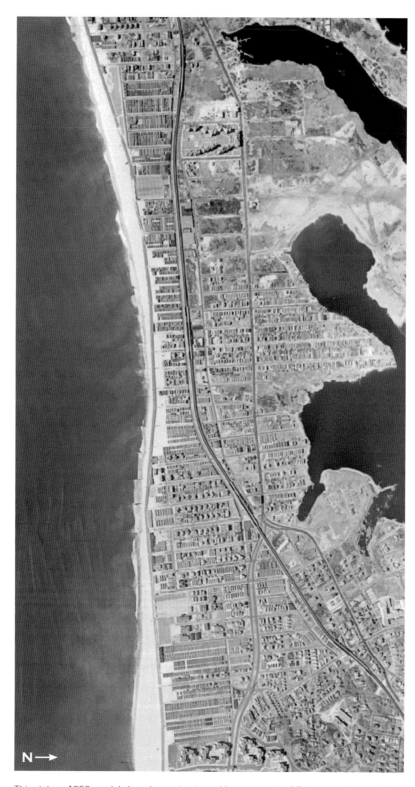

This vintage 1950s aerial view shows streets and houses south of Edgemere Avenue where today is just an abandoned wilderness that doubles as a garbage dump.

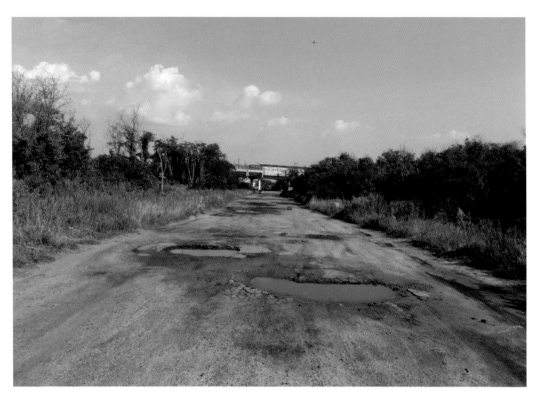

Looking north at the elevated train viaduct from one of the abandoned streets in Arverne, in 2017 (top) and 2019 (bottom). The once paved roads are now full of depressions that make for giant puddles when it rains.

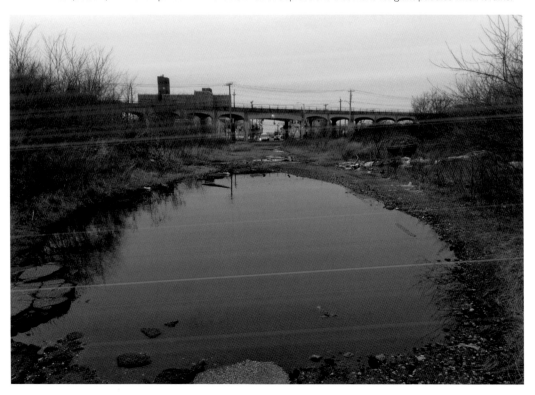

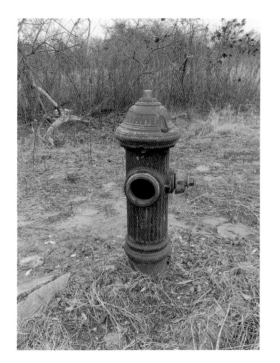

Above left: One surviving bit of infrastructure in the abandoned Arverne neighborhood are the fire hydrants, each one looking quite out of place.

Above right: This fire hydrant is nestled in a cluster of weeds.

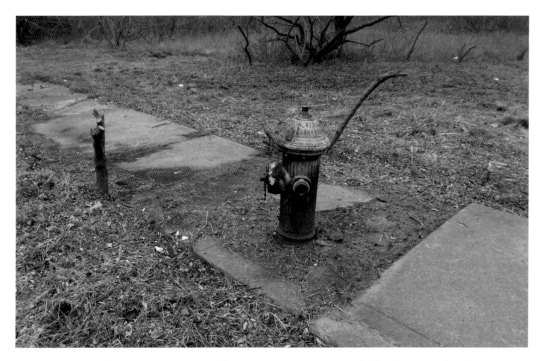

The most haunting of the hydrants I saw was sitting amid a remaining stretch of sidewalk, a reminder of what used to be.

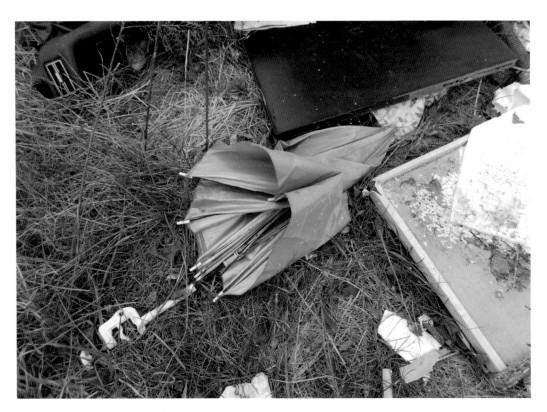

A colorful, broken umbrella lies amongst other random trash.

Readers, welcome to the intersection of Beach 36th Street and Sprayview Avenue. Signs of civilization beckon in the distance.

It's a short walk from Edgemere Avenue down any of the abandoned streets between Beach 33rd and Beach 56th Streets to get to the boardwalk.

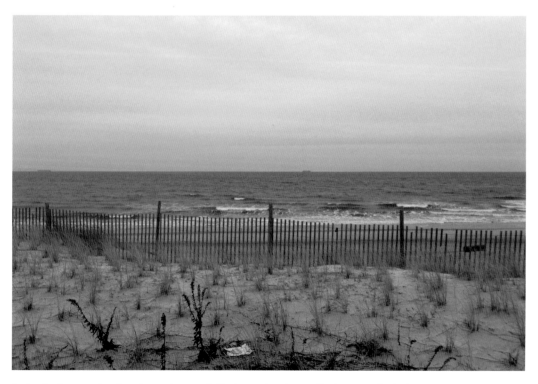

And voila, from an abandoned mess to a sandy Rockaway beach paradise in mere minutes!

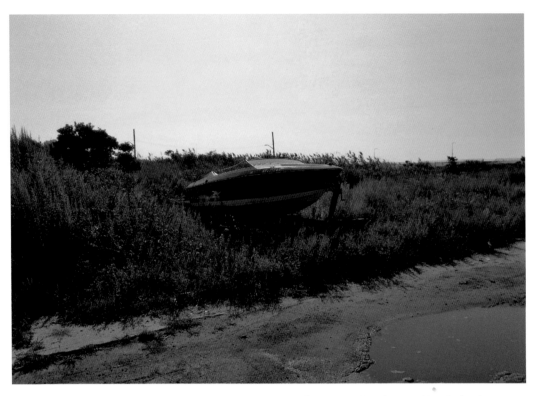

People will dump almost anything imaginable on the side of these abandoned streets. Yes, that's a boat.

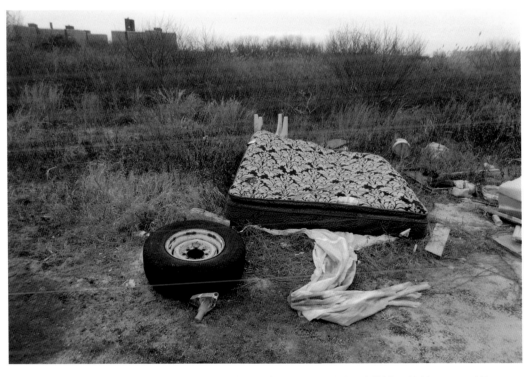

The eclectic mixture of dumped items would make for a bizarre painting. Still Life with Mattress and Tire.

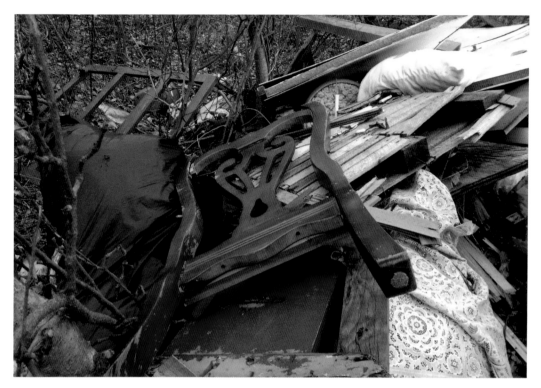

Some of the junk piles are entire rooms full of stuff. I see the back of a dining room chair, a lace tablecloth, and a pillow in this image.

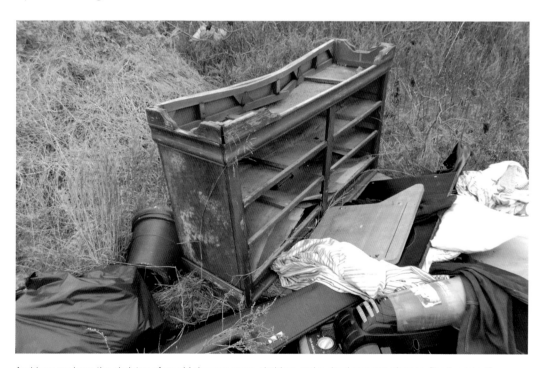

And here we have the skeleton of an old dresser, some clothing, and a dead vacuum cleaner. Really eerie, if you ask me.

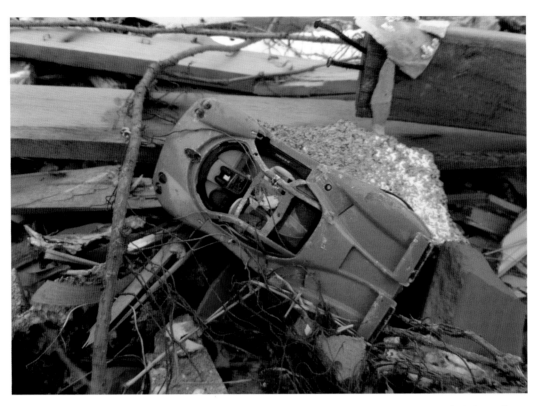

This really struck me—a vintage metal toy race car on top of a pile of random junk. Why and how? We'll never know.

Construction debris? More like destruction debris. Are these leftovers from the demolition of the homes here in the 1960s? Or some more recent junk that was dumped? My guess is that it's recent.

7

CREEDMOOR PSYCHIATRIC CENTER

A bandoned places are the skins we shed over time, as we grow and change–and advance. One good example of this concept is the original Creedmoor Psychiatric Center campus, one of the most haunting, eerie abandoned places in all of New York City. From dozens of functioning hospital buildings at its peak in the 1950s, today's Creedmoor is basically down to one active building, the eighteen-story, 199-foot high building that can be easily seen from a distance and is a prominent sight to passersby on the Grand Central Parkway. Completed in 1959, the tower was designed to house more than 1,000 patients and to supplement an already overcrowded campus that dated back to the 1910s and the conversion of a former rifle range into a mental hospital. But the new building was built at exactly the wrong time, for it was right around then that medications were developed to help people with chemical imbalances. For many potential patients, such treatments were excellent alternatives to commitment to a mental hospital. With the decline in patient population, over the years the older buildings, just south of the new tower, began to close. From a high of 7,000 patients in 1959, the population has declined to just a few hundred patients today. Some buildings look more recently abandoned as evidenced by the signage and other clues, while others seem to have been long since empty.

The campus, located in Queens Village, is owned by the State of New York, and some of the old buildings have been maintained or refurbished and are being reused by various government agencies and non-profits to provide childcare or other social services. Meanwhile, other old buildings sit nearby, abandoned and deteriorating. The contrast between the active and the inactive, the live and the dead, is striking. Just feet away from a parking lot, filled with the cars of those working in a reused Creedmoor building, is a pathway leading to massive empty and crumbling structures.

There appears to be a thriving feral cat population at Creedmoor; on one trip a woman who works in one of the refurbished buildings mentioned how some folks regularly leave food for the cats, evidence of which I have seen in several locations. The cats I encountered eyed me with great disdain and suspicion. Maybe next time I need to come bearing gifts of food.

Not only is there much to explore on the campus, even one long and thorough trip is not enough to get a full appreciation of the place because Creedmoor's appearance changes drastically with the seasons. Springtime brings budding life to an otherwise dead place, but by mid-summer, the pathways and building exteriors have become a tangle of vines and shrubs. Autumn's bright colors bring amazing vibrance to the many trees and to the ivy climbing the walls, and winter exposes more of the structures that are hidden by greenery much of the year.

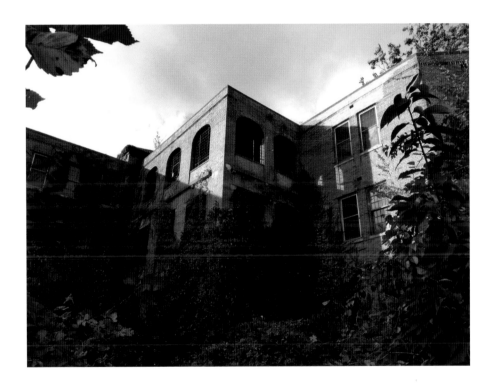

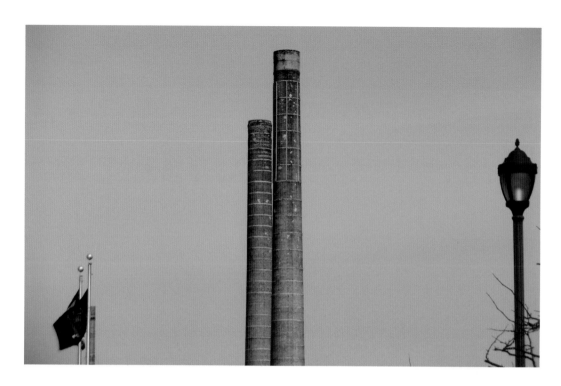

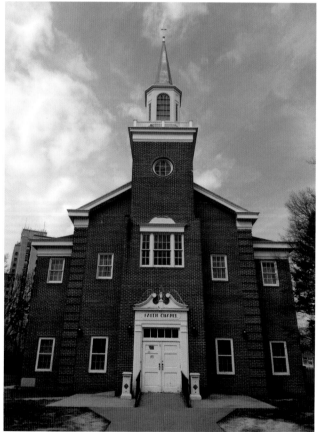

Above: One sight that greets you as you approach the old Creedmoor campus is a pair of vintage smokestacks.

Left: The beautiful Faith Chapel on the Creedmoor campus is still in use today.

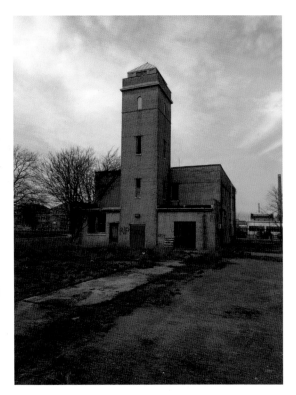

Right: Deeper onto the property, further away from Winchester Boulevard, is where the abandoned buildings are. This striking structure is at the second intersection as you drive into the campus. To its right are a host of abandoned buildings mixed in with a few refurbished and occupied buildings.

Below: An old garage building lies just beyond the towered structure.

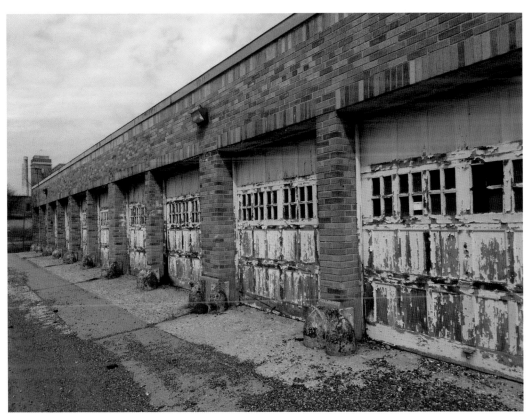

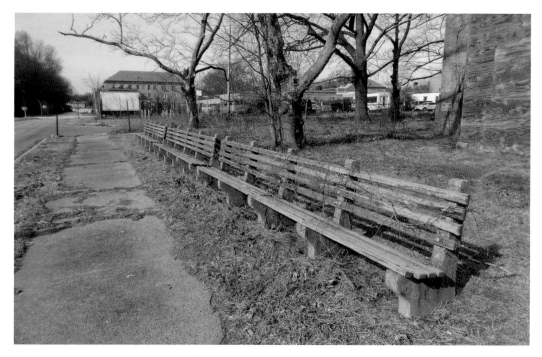

Ancient, empty benches in front of an abandoned psychiatric building. Cars in the background show the ever-present juxtaposition of use and disuse.

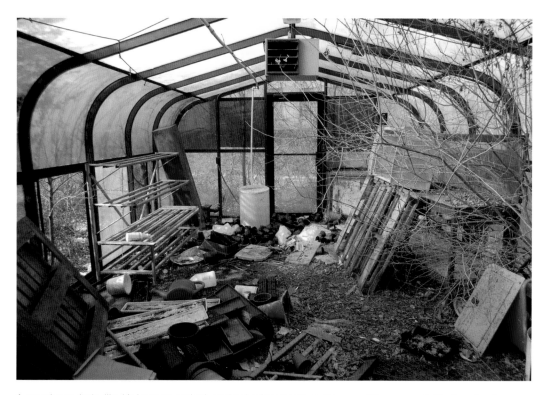

A greenhouse looks like it's been ransacked, or simply abandoned on the spur of the moment. Plastic pots of varying sizes lie on the ground along with other gardening equipment.

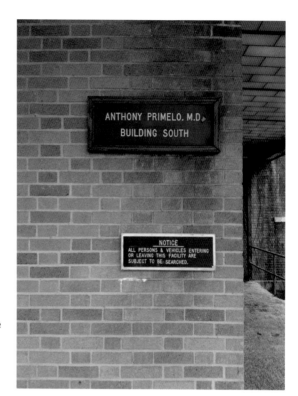

Right: Signage on this building indicate it was abandoned not that long ago. Anthony Primelo was the director of Creedmoor in the 1970s.

Below: A dolly sits in front of the Anthony Primelo Building.

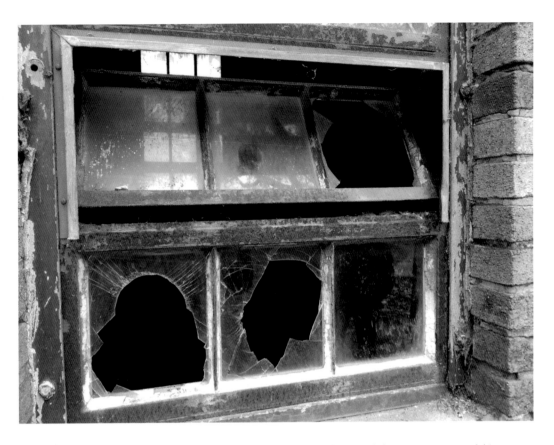

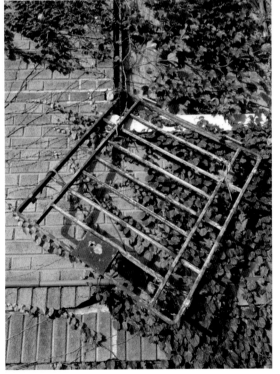

Above: Broken windows are a common sight on the abandoned buildings of Creedmoor.

Left: Hanging grilles and other signs of deterioration abound.

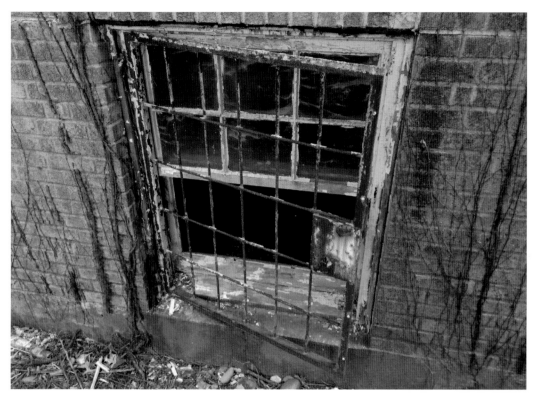

There are numerous potential access points on the ground or basement floors of Creedmoor's abandoned buildings—for squatters and adventurers alike …

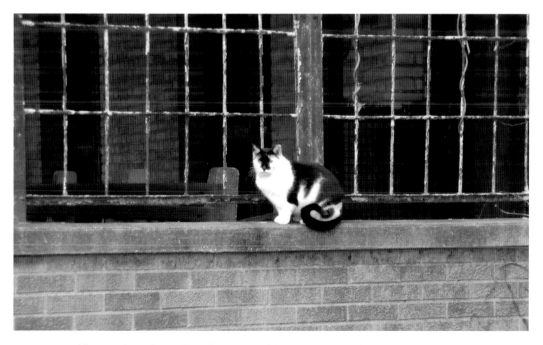

… and for cats. Lots of cats. There is a colony of them living on the Creedmoor campus and inside the old buildings. People regularly leave food for them. I saw several bowls and plates full of cat food every time I visited.

An interesting sign that must refer to the cats and therefore is somewhat recent? It does have a rather old-fashioned look, though.

A vintage something outside one of the empty buildings. There is lots of random junk laying around, some clearly from the heyday of the institution and some more recent.

Above: This rusted toaster oven near Building 25 dates from the 60s or 70s, judging by the color.

Right: A peek inside part of an abandoned building that was being rehabilitated.

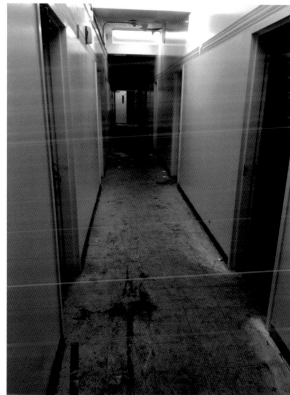

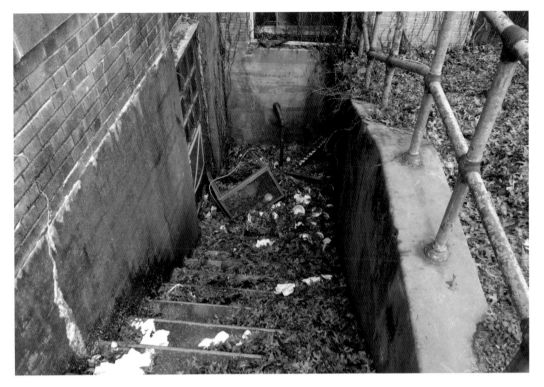

A leaf and trash-strewn stairwell leading to a basement door.

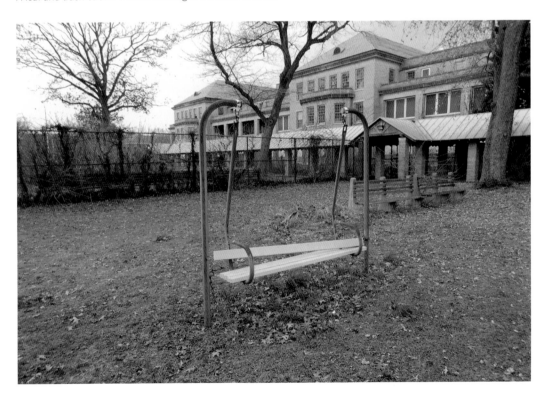

This broken, rusty swing is one of several on the property that once provided recreation for patients.

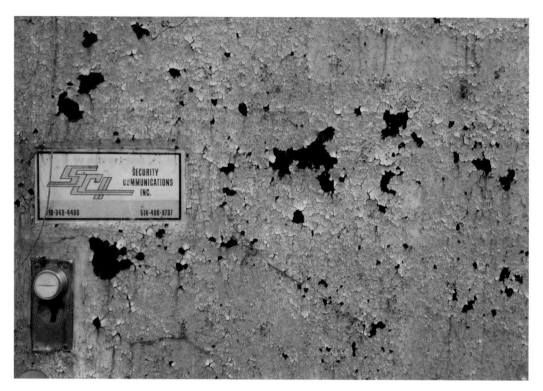

Rust-stained peeling paint and a security sticker on an old/not-so-old door of an abandoned Creedmoor building.

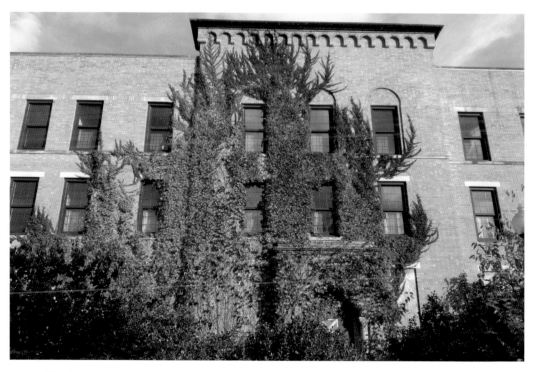

The Creedmoor campus in autumn is alive with color, from the fiery orange and red trees to the bright ivy climbing the building walls.

Pink trash. Who knows how long it had been sitting there when I photographed it?

The architectural details on some of the vintage buildings are exquisite.

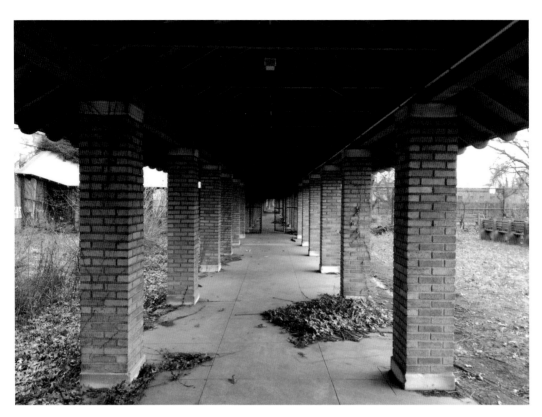

Views such as this one of a passageway fronting an abandoned building are just indescribably eerie.

Looking out from inside, at the passageway in the previous image.

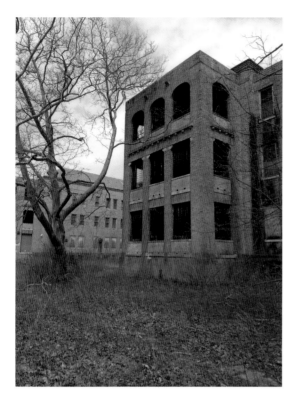

Left: Some of the abandoned buildings' windows are at eye level or lower and allow for a look inside.

Below: An overturned chair, what appears to be an IV stand, and an alcohol bottle are what greeted me when I peeked through one Creedmoor window.

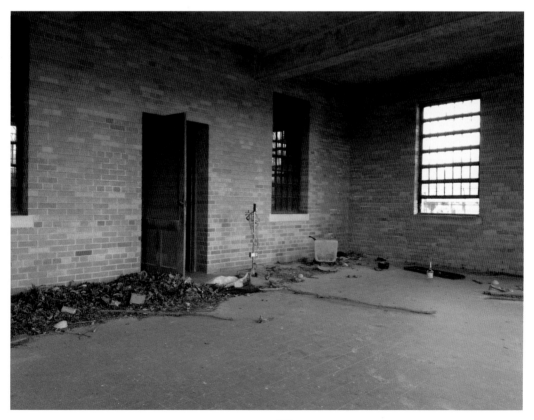

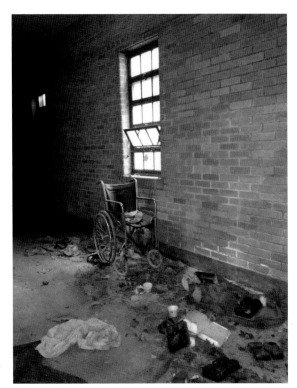

Right: A broken window allowed me to photograph the inside of Building 25.

Below: Also inside Building 25, a rusted table in the foreground and a wheeled table in the distance.

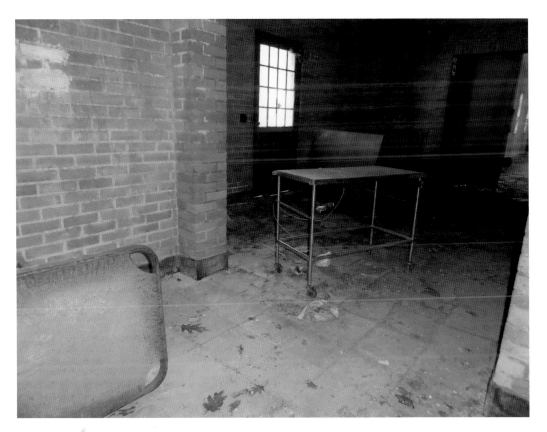

An open window led me into the basement of one of the old buildings, where metal brackets with traces of rags hang from the ceiling.

Looking into an adjacent room I caught a glimpse of a bright red exit sign in striking contrast to the blackness around it.

8

FORT TILDEN

Perched on the western end of the Rockaway Peninsula, further south than any point in Brooklyn, Fort Tilden is the most remote abandoned place in Queens. Named after former New York governor and presidential candidate Samuel J. Tilden, while under construction it was originally called Fort Funston after recently deceased Spanish-American War hero General Frederick Funston.

In its heyday between World War I and the 1950s, Fort Tilden was an important part of New York City's defense system. First opened in 1917, the base had the distinction of having the largest gun in the world. After a two-year-long installation period starting in 1922, the 16-inch gun could fire a 2,400-pound missile 25-30 miles, and as the local newspaper *The Wave* put it in an article on September 4, 1924: "If a battleship be sighted out at sea, the gun is lowered, all by electricity, the range found, the gun let go, and if the battleship be within 30 miles of the shore [it] will be blown to smithereens. Demonstrations of the latest gun show that as a destructive agent it is the last word in defense guns."

Despite the presence of this intimidating weapon, Fort Tilden maintained a skeleton crew after World War I, with only thirty men stationed there for years, still residing in the makeshift wooden barracks that were built in 1917. Fort Tilden did not reach its full potential until the World War II era, when construction ramped up and many more soldiers were assigned to the base. By this time, more than ninety sturdier buildings had been erected on the site. A 1943 newspaper headline from *The Wave* proclaimed the new construction, saying: "Vets of '17 and '18 Would Not Know the Place Today."

After World War II, Fort Tilden became home to a newly developed technology that was designed to shoot down high-altitude Soviet planes. The Nike missile (later

known as the Ajax missile) was the first surface to air missile. At 32 feet long and 32,000 pounds, it had a range of 30 miles, could reach 70,000 feet, and a speed of 1,725 miles per hour. A few years later, it was replaced with the more advanced Hercules missile.

Other Long Island missile sites were located in Lido, Brookville, Lloyd Harbor, North Amityville, and Brookhaven. All this serious defense stuff seems like it would have been top secret hush hush, but each of the missile sites were open to visitors every second Sunday afternoon of the month!

There was talk during the 1960s of Fort Tilden closing, and finally in 1974, the National Park Service acquired the property, and the missile system was removed.

With such a fascinating history, I was naturally eager to explore the place and see what was left of it. I parked at the Jacob Riis parking lot on a hot summer day and walked west to Fort Tilden. The buildings on the northeastern edge of the property have been reused as, among other things, artist studios and theater performance space. There are also baseball and soccer fields, and the old base chapel still stands. It feels like a community, like a friendly place. But take a walk further west and you'll be met by a trail leading into a wilderness of small abandoned buildings and 16-inch gun battery installations.

Also of note in the immediate area is neighboring Jacob Riis Park, which used to be home to Fort Tilden's military sibling, Naval Air Station Rockaway. This air base sealed its place in history in 1919, when three navy seaplanes took off in an attempt to be the first to cross the Atlantic Ocean. Two of the planes failed, but the third made it across–in a series of hops-skips-jumps stretched out over many days. It was the first time an aircraft flew across the Atlantic, and a full eight years before Charles Lindbergh would make the first solo non-stop flight across the Atlantic. The Naval Air Station was closed in 1930 and converted into the park, whose Art Deco bathhouse building is itself abandoned and in need of restoration.

The easiest access is via the Marine Parkway Bridge from Brooklyn or the Cross Bay Bridge from Queens. Despite being so far removed from the rest of Queens, Fort Tilden is worth a trip for sure if you fancy a mixture of sand, sun, surf, and surreal.

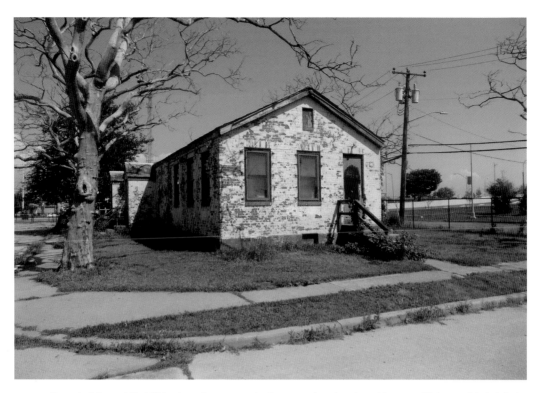

Some buildings at Fort Tilden have been reused, others are abandoned, and for some it's impossible to tell at a glance which category they fall under.

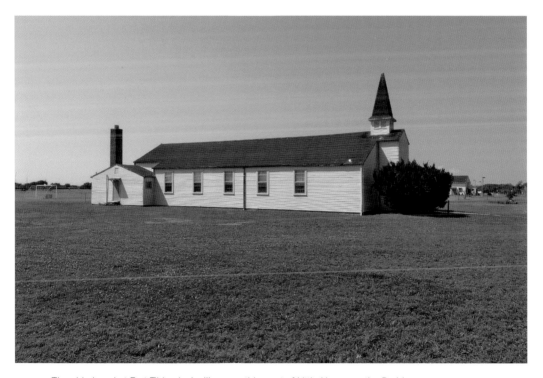

The old chapel at Fort Tilden looks like something out of Little House on the Prairie.

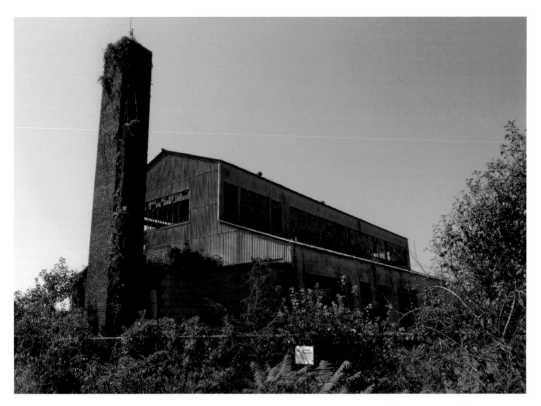

Two views of an abandoned warehouse at the edge of the trails leading deep into the heart of abandoned Fort Tilden.

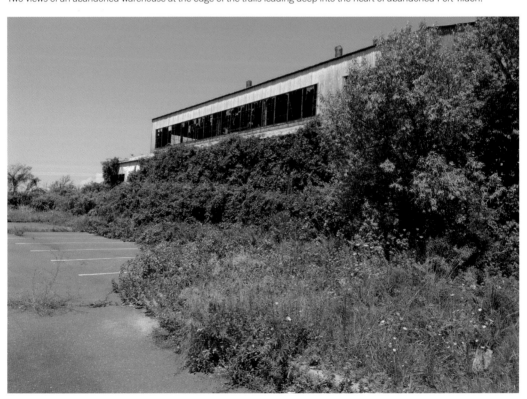

Walking along the trail, you'll catch glimpses of small old buildings partly hidden under weeds and brush.

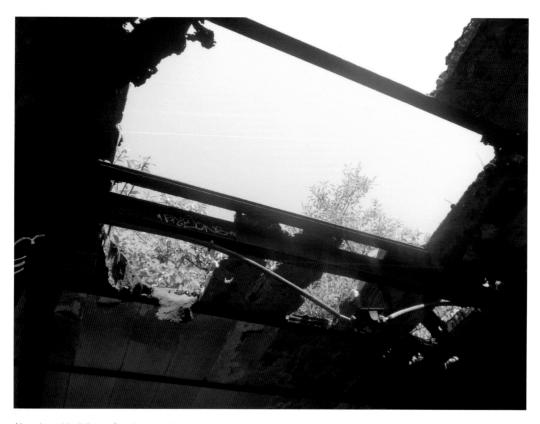

Abandoned buildings often have accidental skylights.

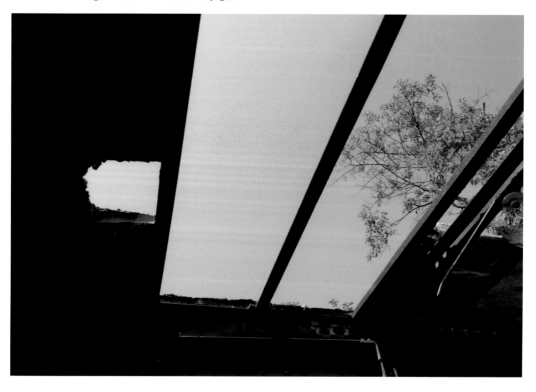

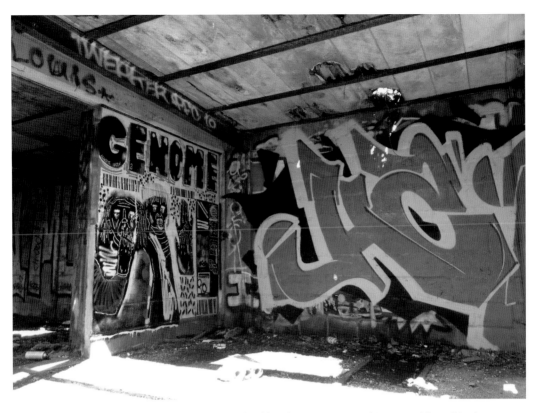

Graffiti inside an abandoned munitions building. Note the empty spray-paint cans and the rail tracks.

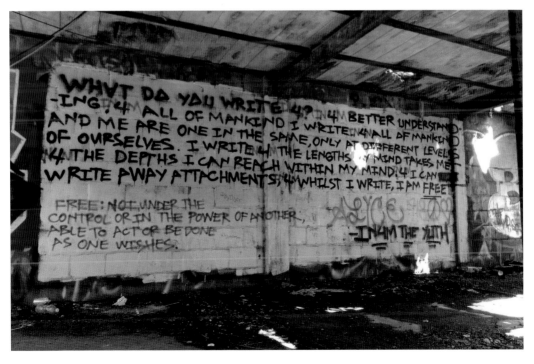

The walls of abandoned buildings allow poets to share their thoughts.

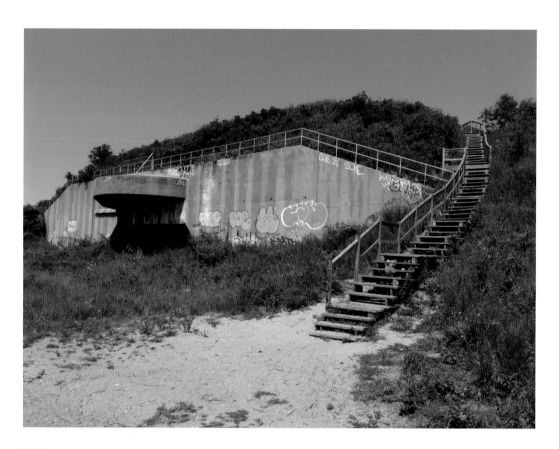

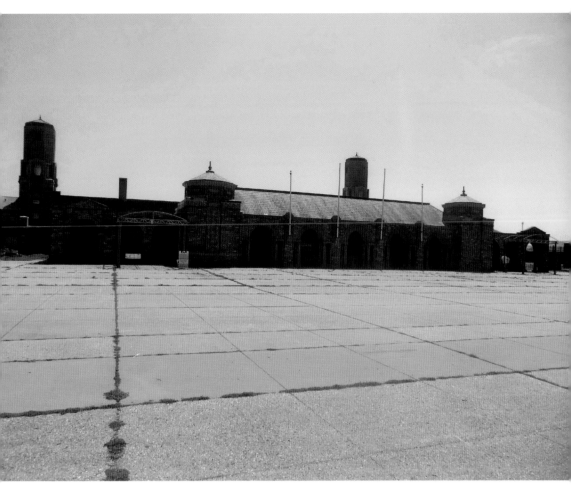

The neighboring Jacob Riis Park building is itself abandoned and awaiting renovation.

Opposite above: Battery Harris East used to house 16-inch guns. Now empty of its munitions, the concrete installation is still an imposing sight.

Opposite below: The view from atop Battery Harris East. The Atlantic Ocean is visible in the distance.

9

FORT TOTTEN

Though the Civil War was not fought anywhere near Queens, the borough nonetheless can stake a legitimate claim to a piece of Civil War history. If you take Exit 32 (Bell Boulevard) off the Cross Island Parkway, the last exit in Queens before the Throgs Neck Bridge, you'll find yourself at the doorstep of a Civil War-era fort.

Once a fully active military base, the Fort at Willets Point (in 1898 it was renamed Fort Totten after Brigadier-General Joseph S. Totten) was built on what was known as Willets Point (not to be confused with the Willets Point in Flushing near the Mets' stomping ground), a 147-acre peninsula on the Long Island Sound in Bayside. Beginning in 1862, Willets Point was home to a recruit depot/temporary encampment for troops heading to off to war. In 1864, a large hospital was built, and more than 5,000 patients passed through before war's end. After the Civil War was over, Fort Totten became home to the U. S. Engineering School of Application for the next thirty-five years. The fort's most famous visitor may have been Secretary of War Robert T. Lincoln, Abraham Lincoln's son, who visited in 1884.

The fort continued to be important during the World War I era. On one occasion in 1915, tests of the big guns were held, firing at off-shore targets several miles away. Residents in a five-mile radius, in Corona, College Point, Flushing, and Whitestone were told to take precautions against the earth-shaking vibrations that the shots would cause, including leaving their windows open at least six inches to prevent shattering, leaving all their doors partly opened, removing heavy pictures and mirrors from walls, and placing all glass or china items nestled safely on the floor.

As of 1939, Fort Totten was protected by 3-inch anti-aircraft guns, 30-calibre anti-aircraft machine guns, and 50-calibre anti-aircraft machine guns. The 3-inch

guns could fire to an altitude of about 27,000 feet or five miles or a horizontal distance of about seven miles. Also present was an 800 million candlepower searchlight to locate and illuminate enemy aircraft.

Though the military base is no longer in operation, Fort Totten, like its southern Queens counterpart Fort Tilden, still shows many signs of life. As of 2019, Fort Totten was home to a US Army recruiting station, a couple of Fire Department training facilities, a Police Department training facility, and the Bayside Historical Society (headquartered in the historic vintage 1887 officers club building originally known as the "Engineers Castle Club" designed to look like a castle, the symbol of the Army Corps of Engineers). Besides the actively used buildings, much of the former fort is now run by the New York City Parks Department as Fort Totten Park (adjacent to the east is Little Bay Park). There's even a public swimming pool! During the summer, hundreds of people use the pool daily, coming by bicycle, car, or bus to take advantage of the facilities.

But amidst all the reuse and activity are scenes of decay and abandonment. The crumbling buildings on the following pages sit wearily across from refurbished ones. Other buildings look like they are currently in use but are in need of repairs. The entire Fort Totten area is worth a thorough walk, an afternoon spent wandering amidst the new and the old. The old *circa*-1829 Willets homestead still stands, too, and there are plans to stabilize and restore it. All hope is not gone for the abandoned buildings. One of the most interesting abandoned buildings is as of 2019 being converted into the Center for the Women of New York, a women's history, conference, and career education center, according to the sign the city posted. Fort Totten is a pleasant place to walk, full of hidden corners and surprises. The stunning waterfront views would be worth it even without the allure of abandoned buildings.

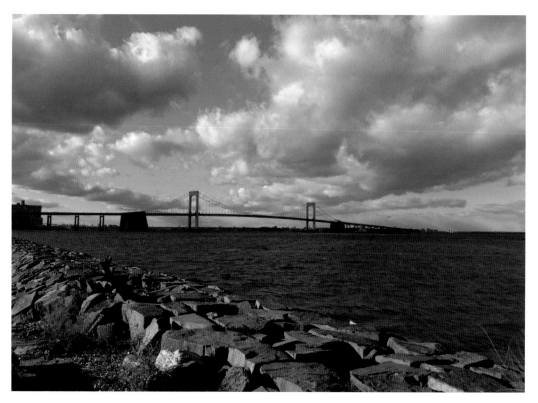

Fort Totten and neighboring Little Bay Park offer great views of the Throgs Neck Bridge.

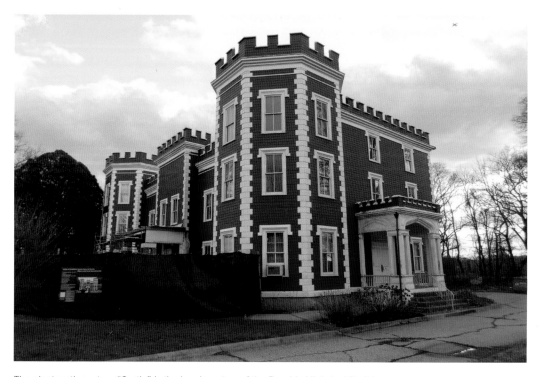

The nineteenth century "Castle" is the headquarters of the Bayside Historical Society.

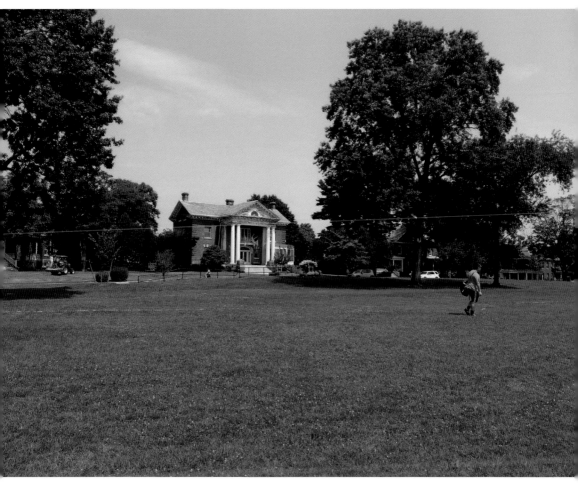

Green lawns, a public swimming pool, and a mix of abandoned and occupied buildings make Fort Totten a great summertime day trip adventure.

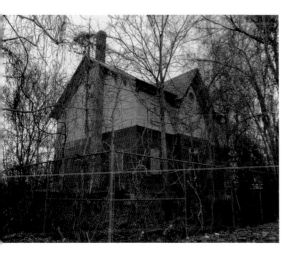 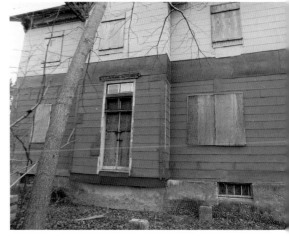

The oldest building at Fort Totten is the Willets farmhouse, which dates to the early nineteenth century. This abandoned structure is awaiting restoration to save it from crumbling.

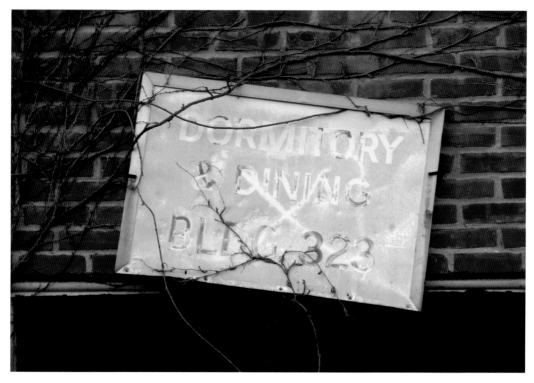

A vintage sign for Building 323, a late-nineteenth-century barracks that is now crumbling.

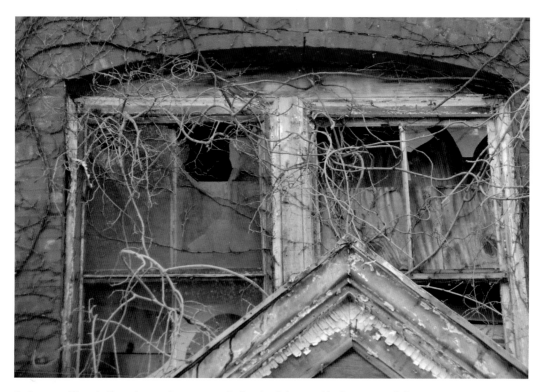

A close-up of the windows above a doorway reveal a tangle of vines and broken panes of glass.

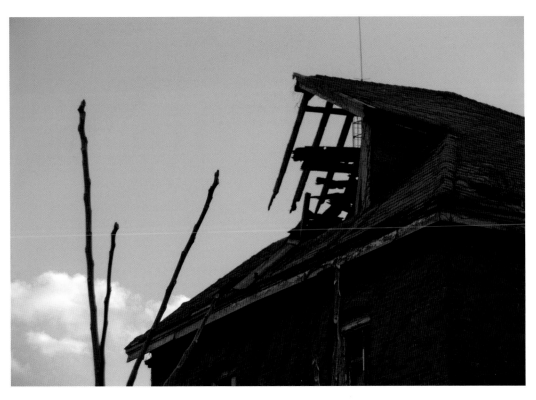

Two roof shots. Decay can be beautiful.

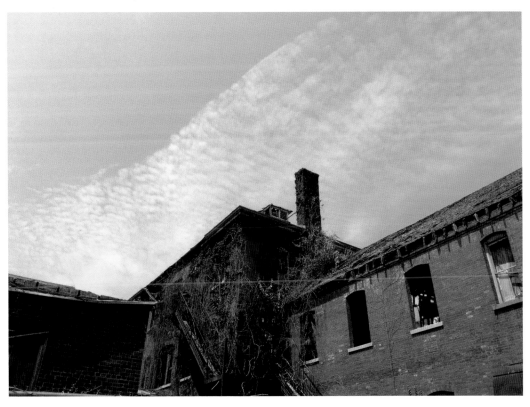

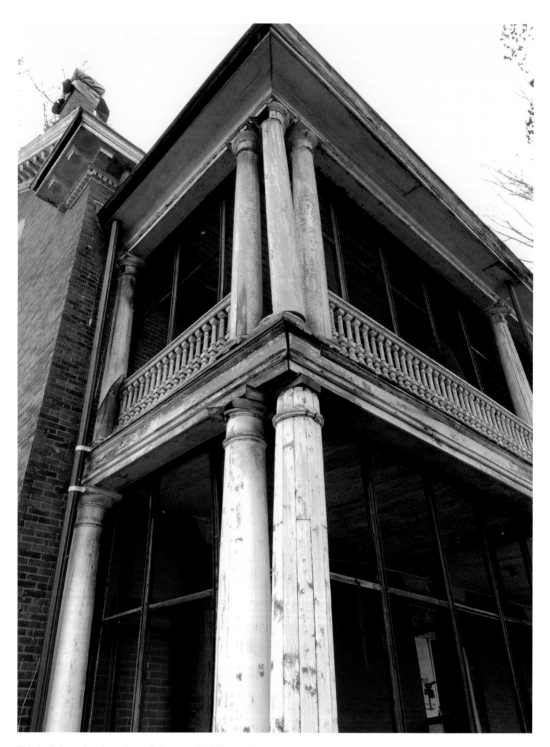

This building, abandoned and forlorn as of 2017, was being renovated as of 2019 and will become The Center for the Women of New York.

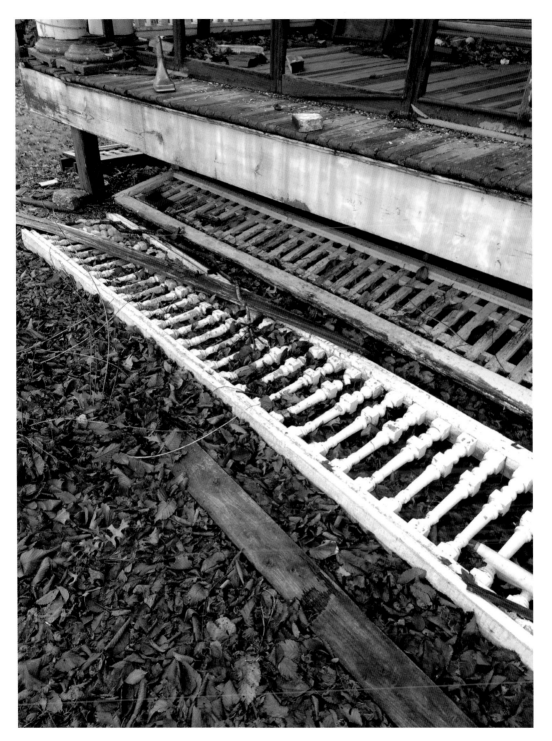

Broken, fallen railings lie in front of the building in 2015.

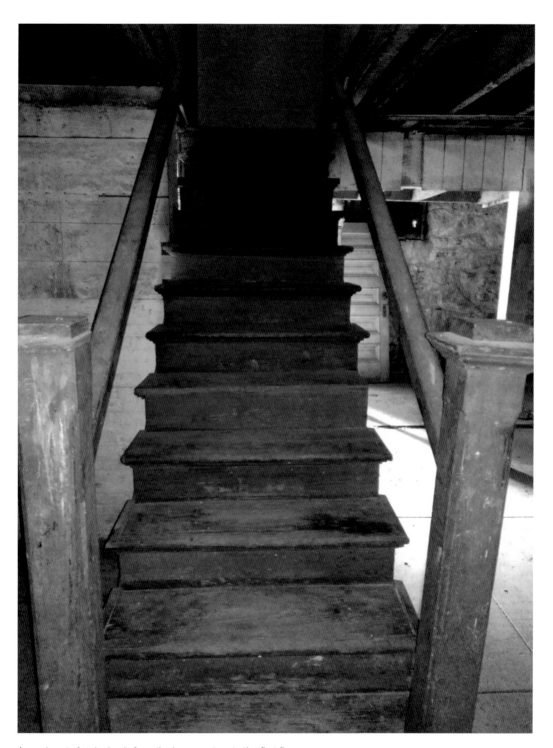

An eerie set of stairs leads from the basement up to the first floor.

A stairway from the first to the second floor, and what appears to be an original tin ceiling offer a glimpse the former glory of the abandoned buildings of Fort Totten.

Left: Two ancient doors sit in the summer sun outside an abandoned red brick building.

Below: Exploring the far corners of Fort Totten reveals more hidden treasures, such as the ruins of this vintage concrete structure I photographed in 2015.